AMOK BOOKS
Kaleidoscopics
BOOK 2

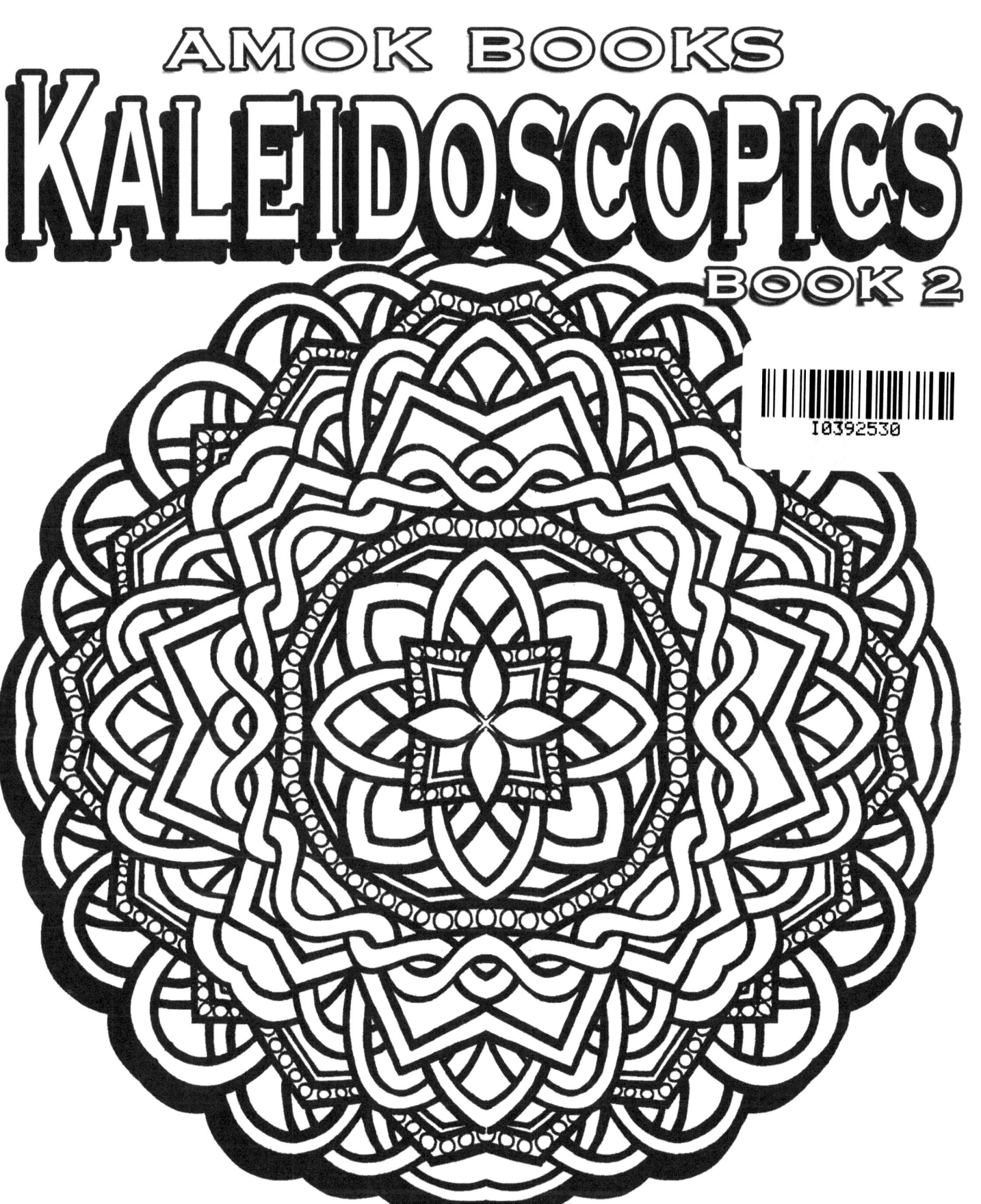

Dave Weiss
AMOKBOOKS, MOHRSVILLE, PA
DWEISSCREATIVE.COM

Why Kaleidoscopics?

Some people call them Mandalas, but I'm just not comfortable with that. Mandalas are sometimes associated with eastern religious rituals and that's not the direction I'm taking. To me these pieces are a departure from what I usually do. They are created in pieces and cut together into the images you see before you and while I have some idea what the final piece will look like, it is often a very pleasant surprise. It's as if the piece is seen through that favorite childhood toy, a kaleidoscope.

I think of my work on these pages as a kind of artistic jam session—giving my creativity wings and letting it soar. It is my hope that you, the colorist, will do the same. There is no right or wrong way to interpret these, only your way. Have fun with them. Get your materials out and let your creativity take flight. Whether you are coloring just to relax or you're trying to recapture your creativity, know this. You are creative and you are an artist. Pablo Picasso once said, "All children are artists, the problem is to remain one as one grows up."

Welcome back to art. The sky's the limit! Have fun!

© 2016 by David C Weiss

All rights reserved.
Published Mohrsville, Pennsylvania, by David C. Weiss for AMOK Books. AMOK Books, AMOKArts and A.M.O.K. Arts Ministry Outreach for the Kingdom are trademarks of David C. Weiss

Illustrations by David C. Weiss, AMOKArts.com

ISBN-13: 978-1535448147;
ISBN-10: 1535448148

Library of Congress Cataloging-in Publication Data

Weiss, David C., 1963-
Kaleidoscopics: Book 1, 50 Images to Color by David C. Weiss

ISBN
1. Weiss, David C., 1963- 2. Art
3. Coloring

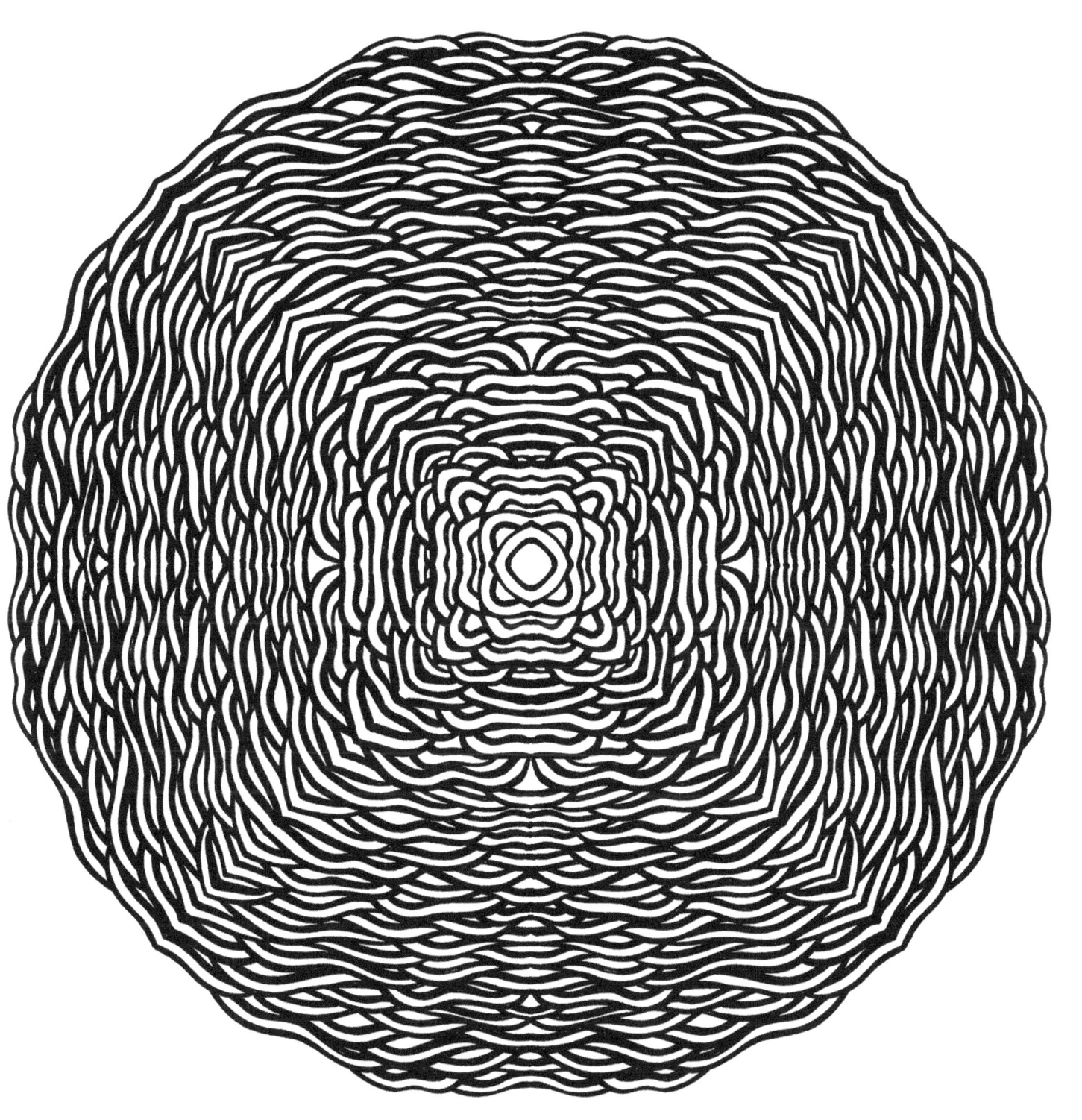

Kaleidoscopics Book 2
"A Tisket, A Tasket"

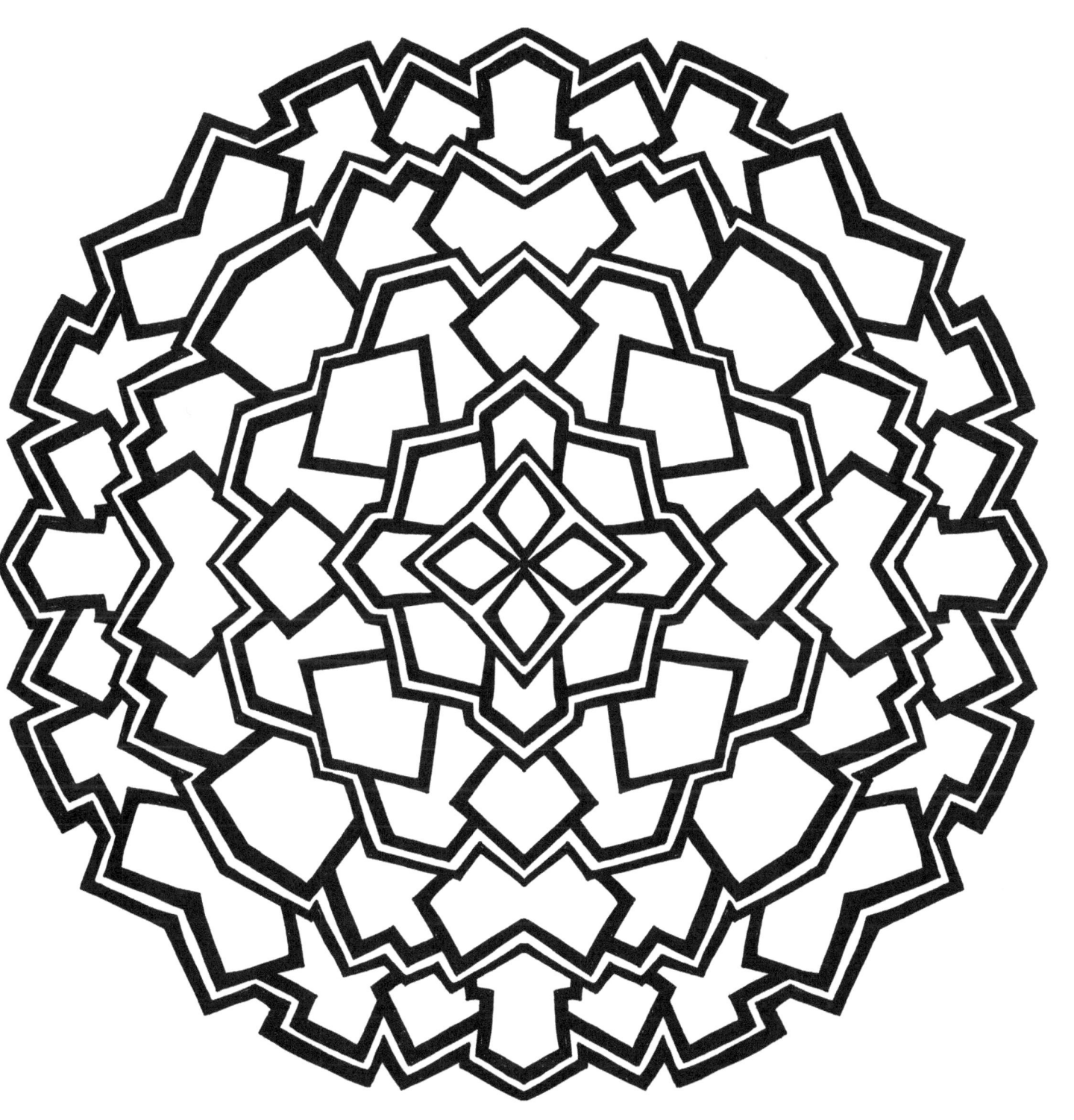

Kaleidoscopics Book 2
"Angular Anarchy"

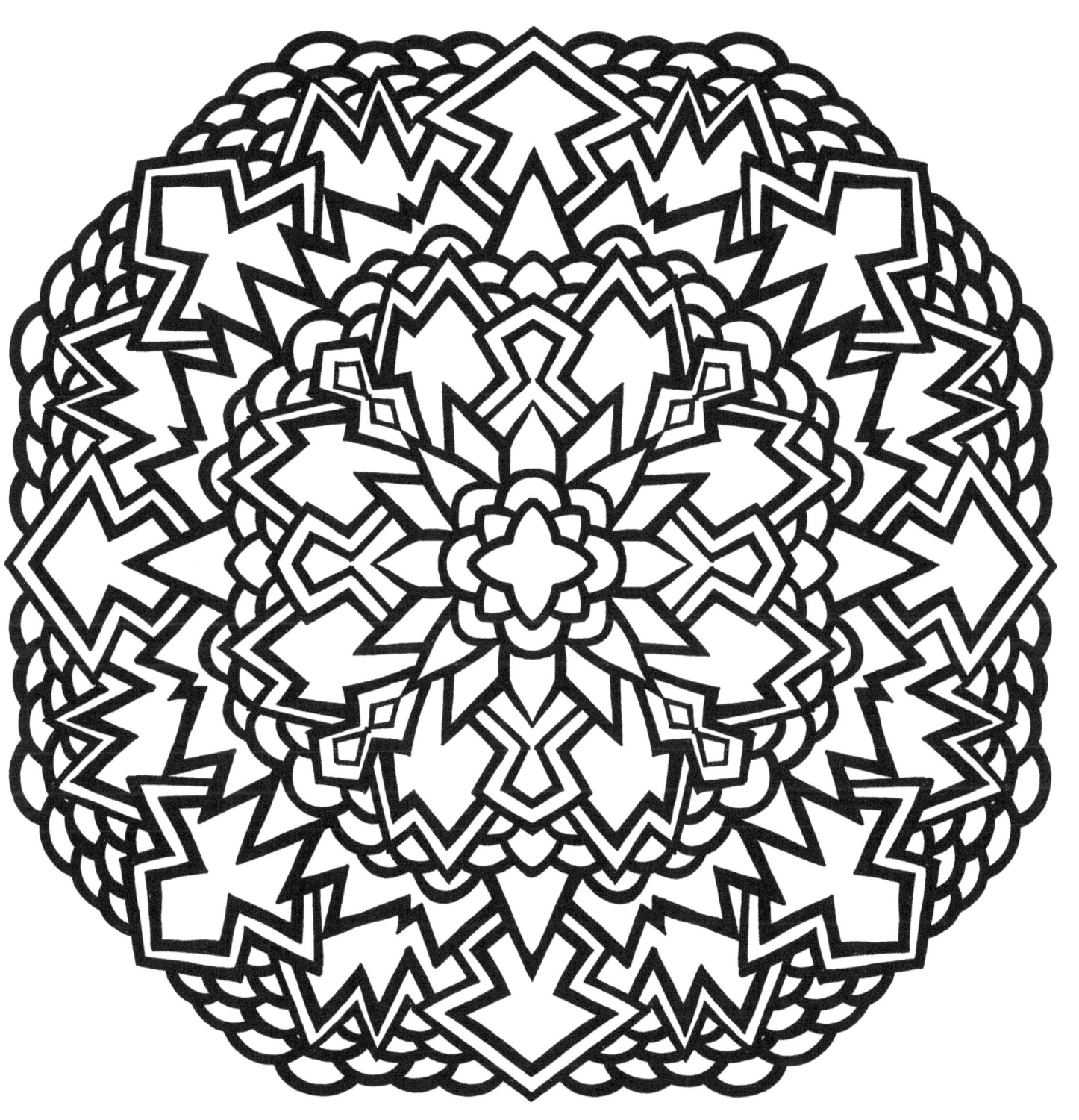

Kaleidoscopics Book 2
"Bumps and Angles"

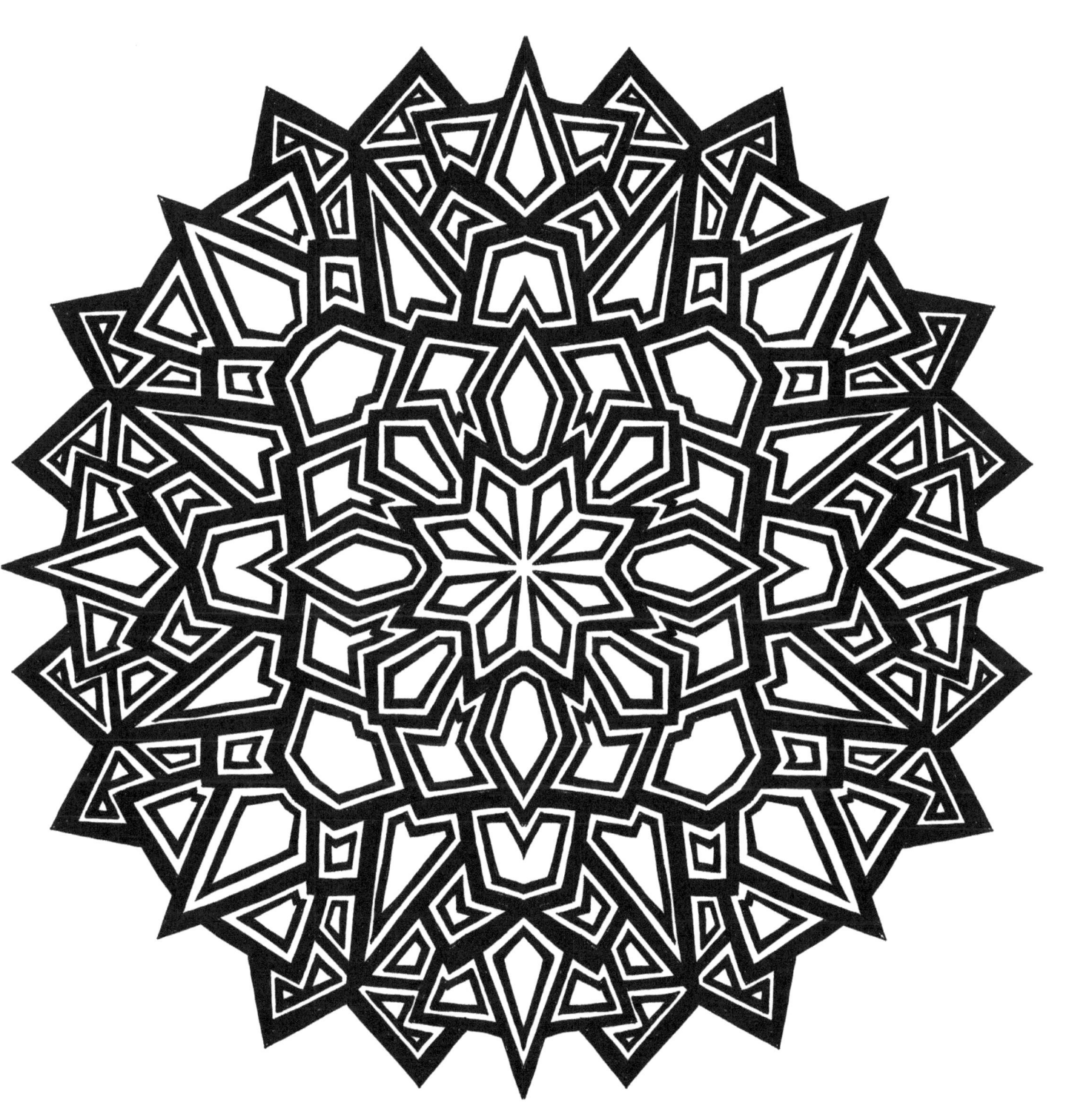

Kaleidoscopics Book 2
"Flakey"

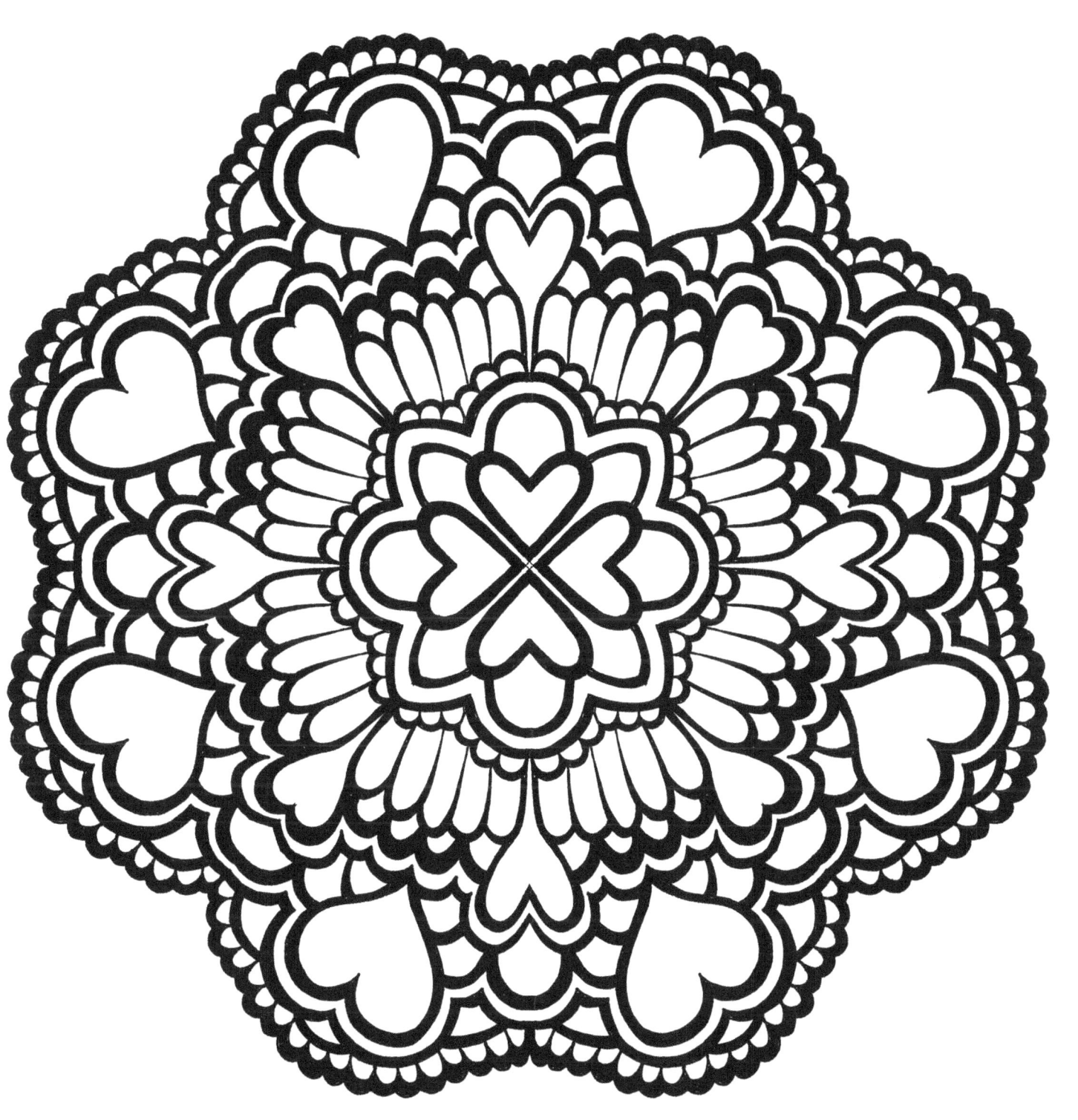

Kaleidoscopics Book 2
"Hearty Lace"

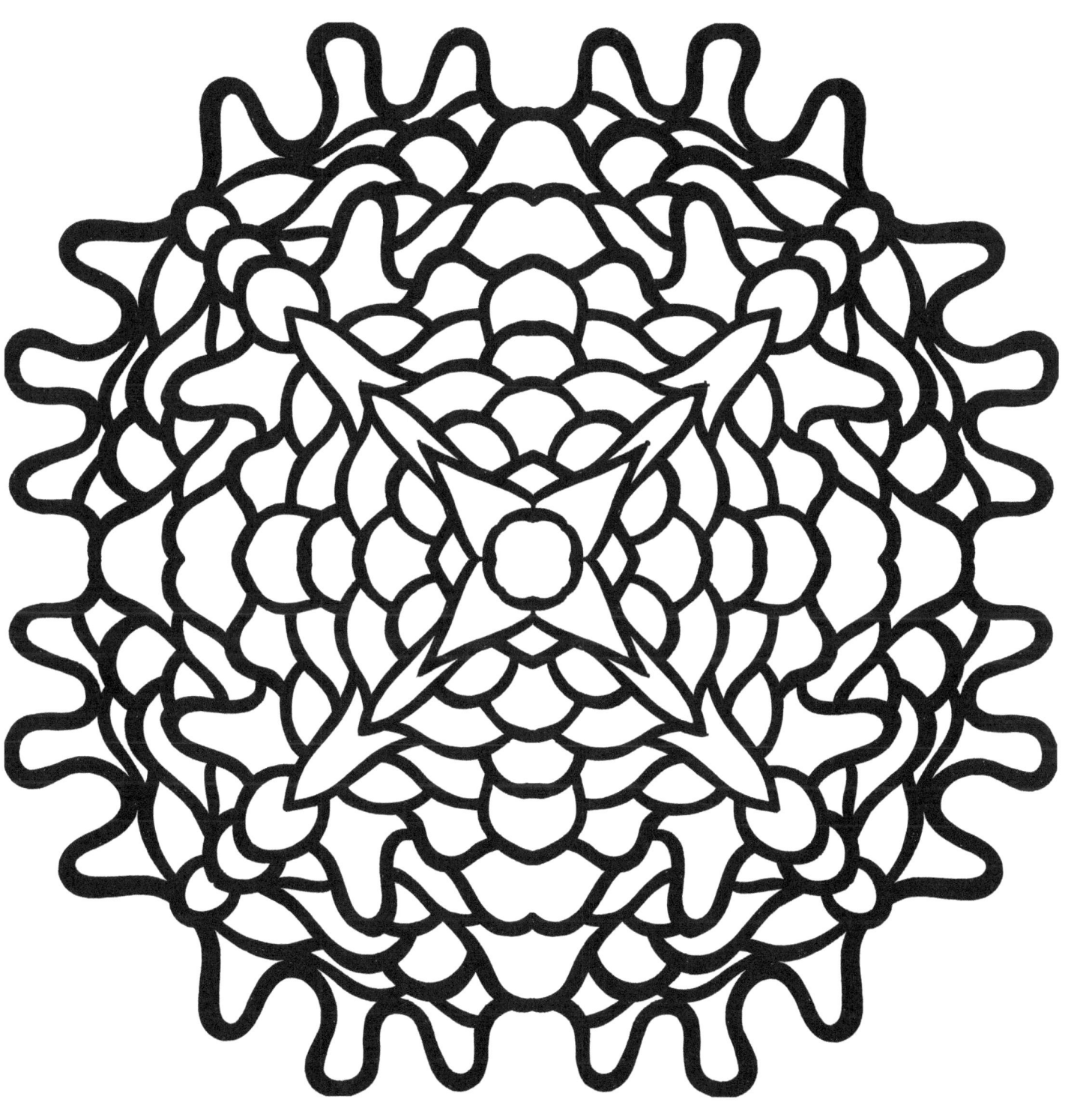

Dave Weiss

Kaleidoscopics Book 2
"Wiggly"

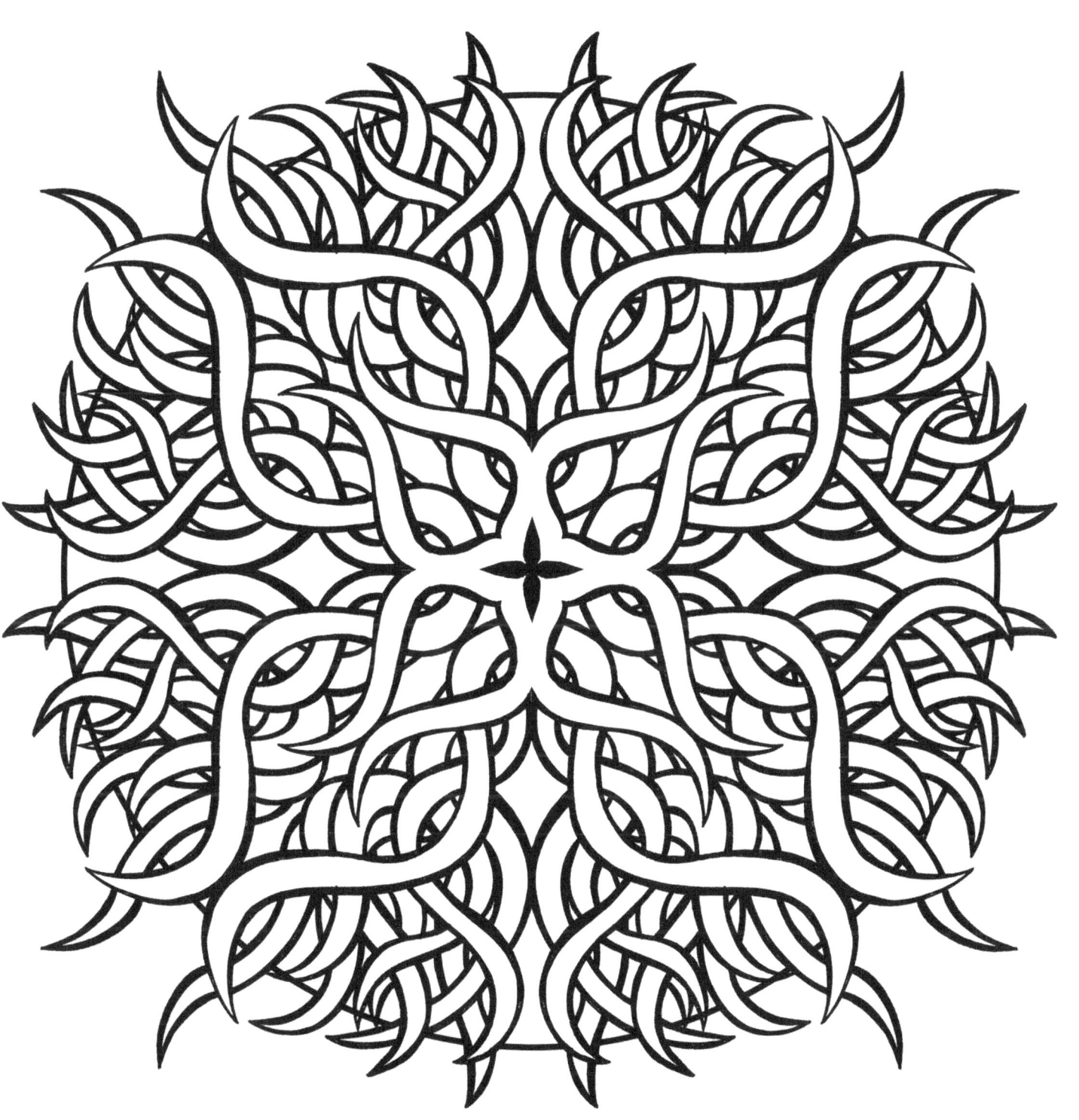

Kaleidoscopics Book 2
"Seaweed"

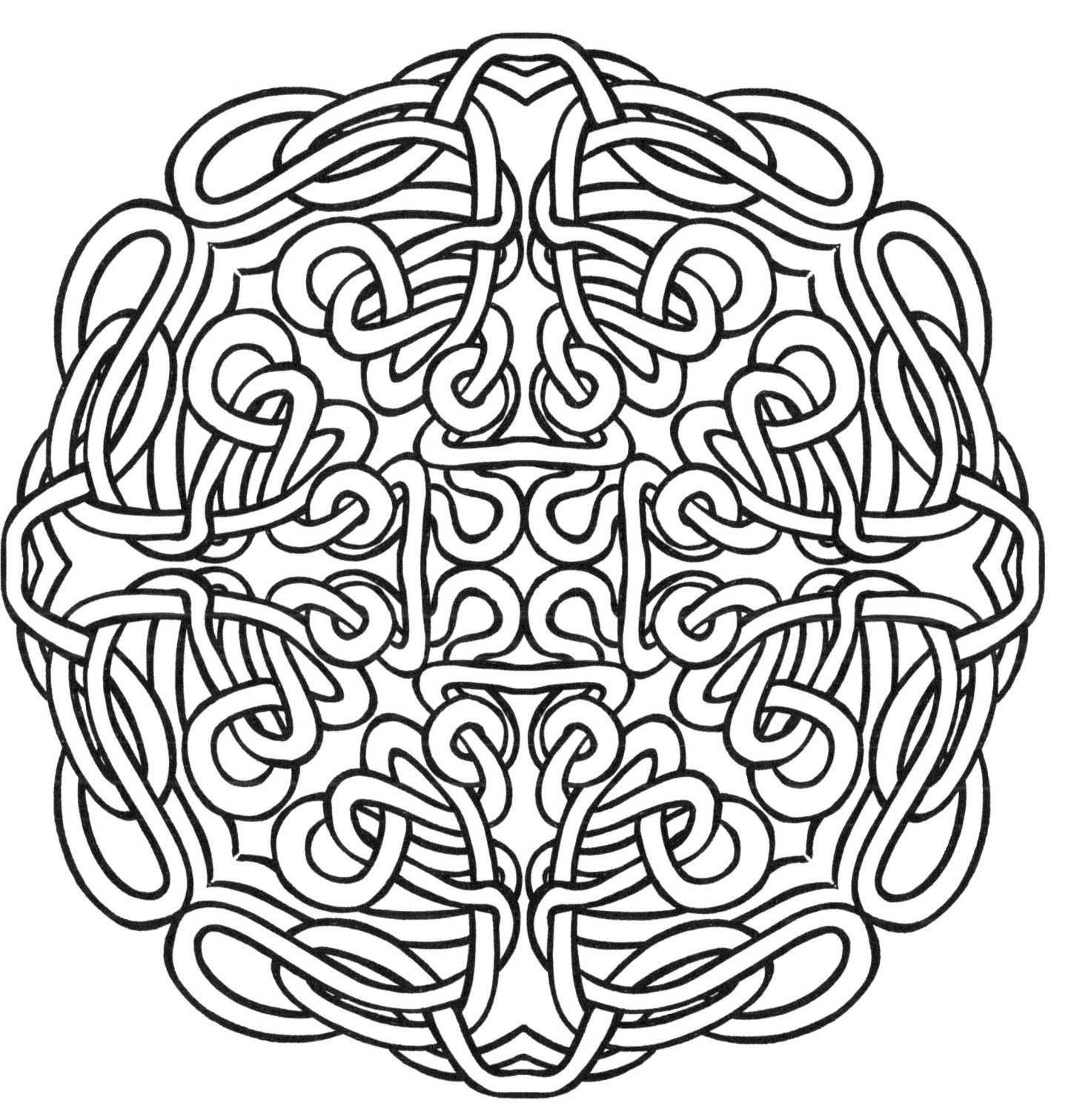

Kaleidoscopics Book 2
"Feelin' Loopy"

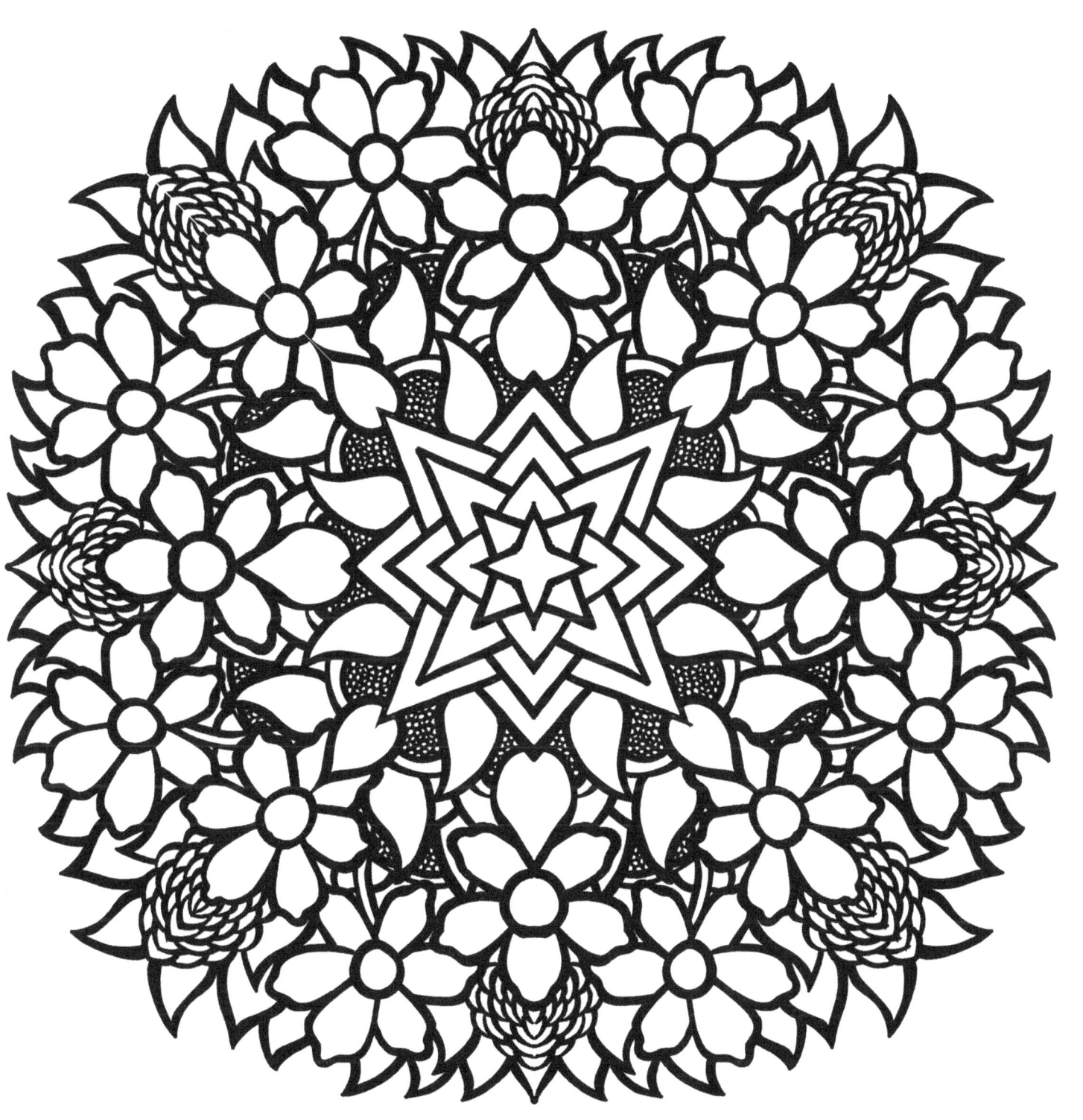

Kaleidoscopics Book 2
"Garden Fountain"

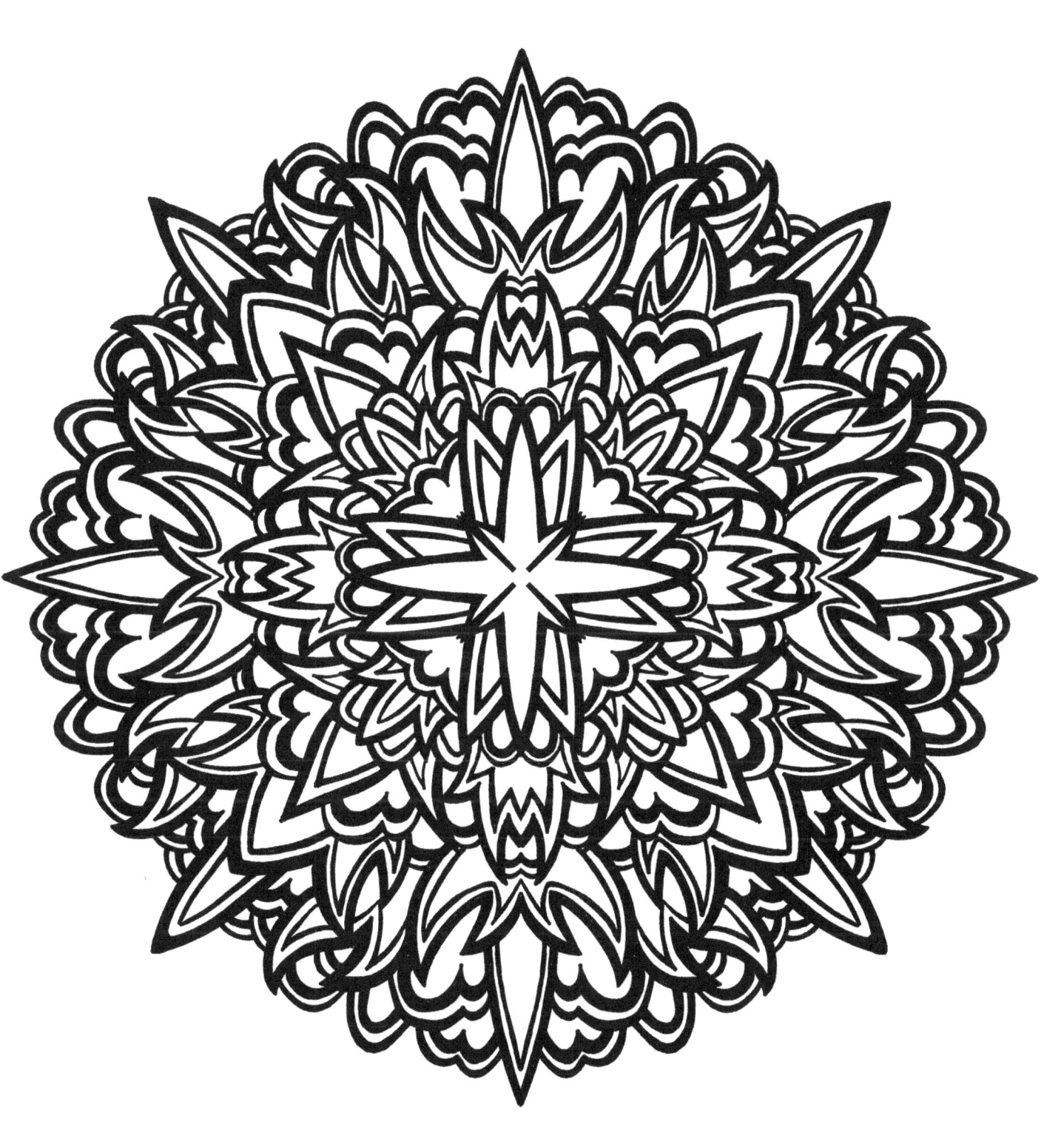

Kaleidoscopics Book 2
"Sword Flower"

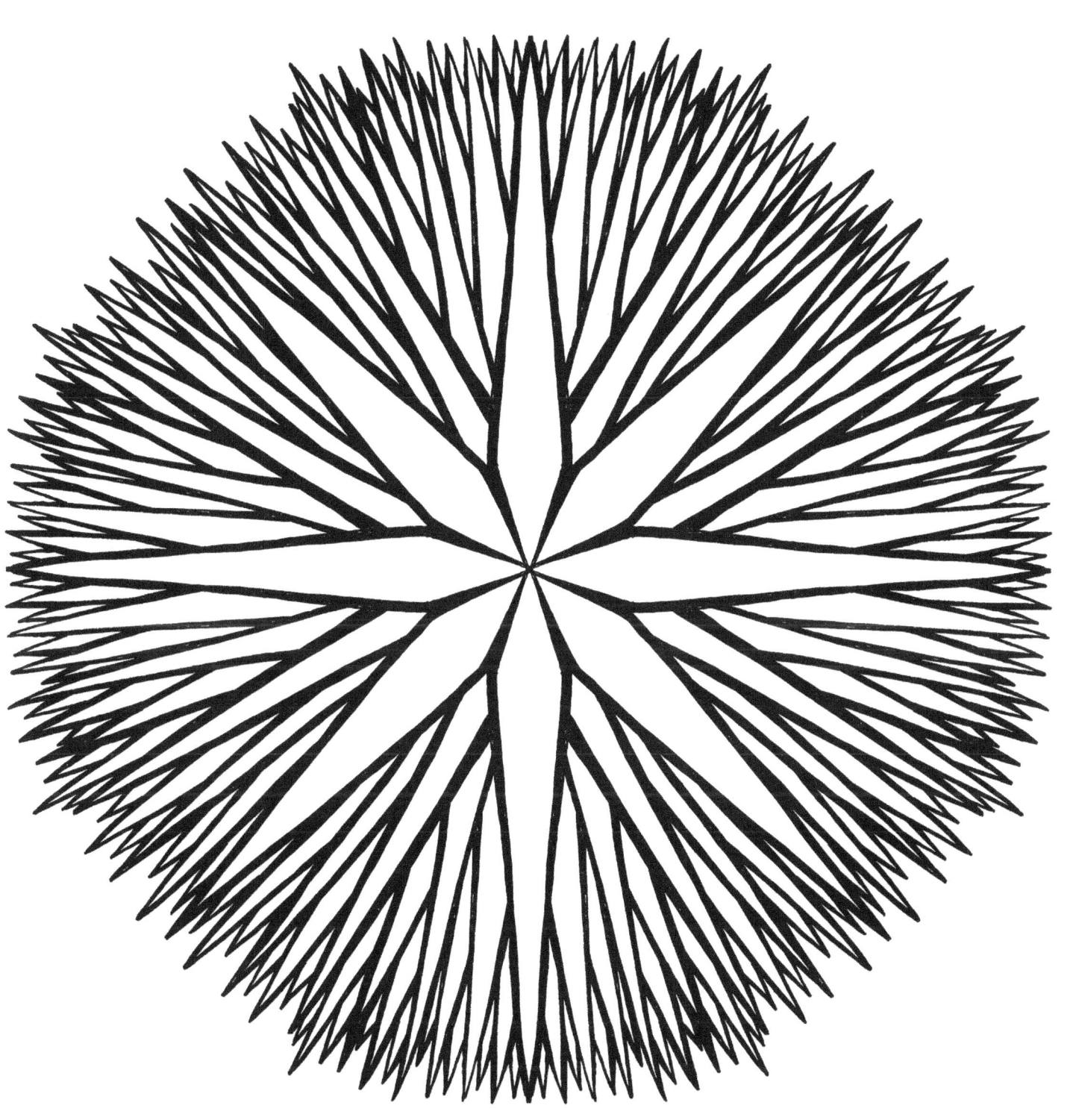

Kaleidoscopics Book 2
"Urchin-tly"

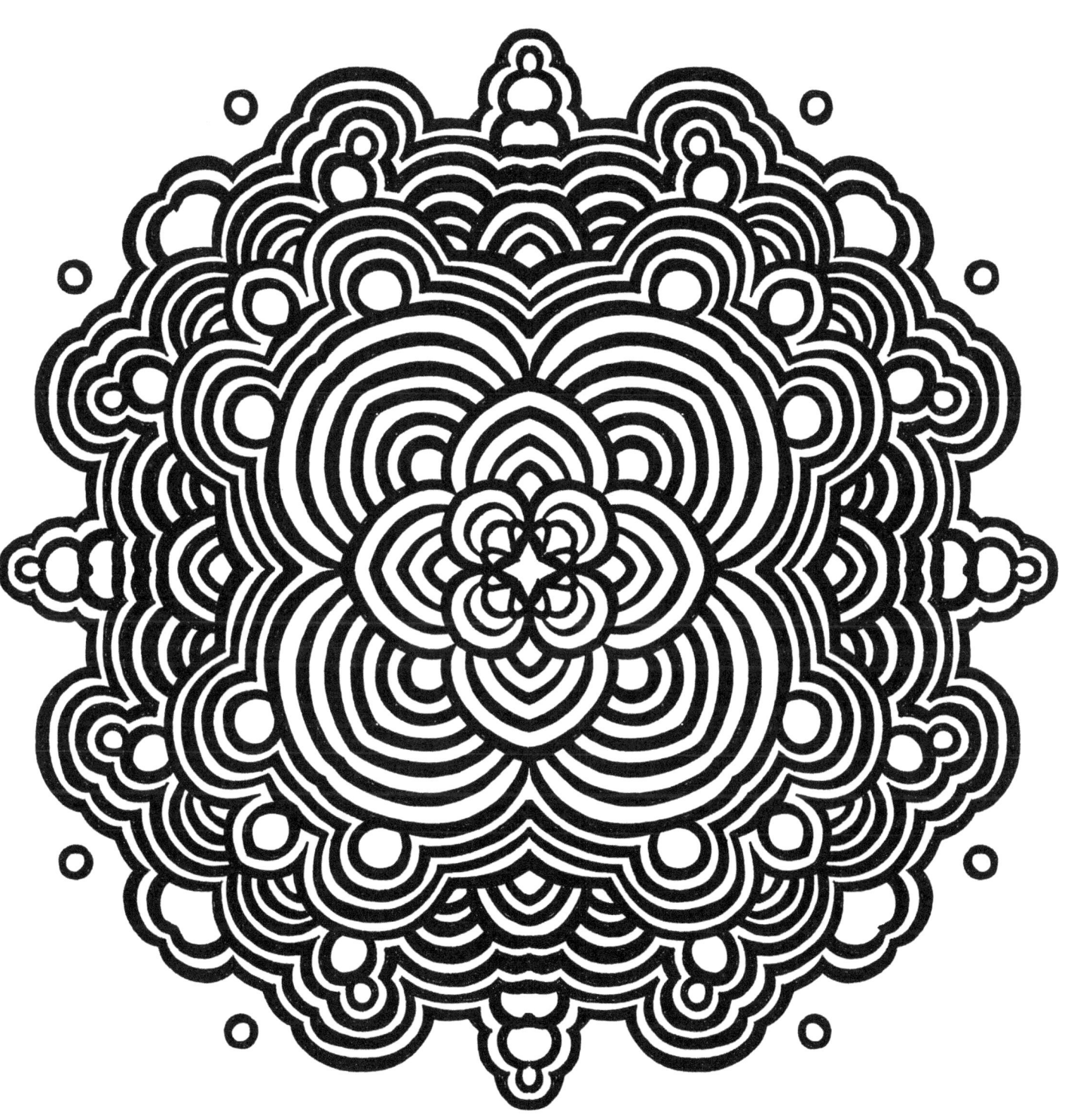

Kaleidoscopics Book 2
"Archey'''

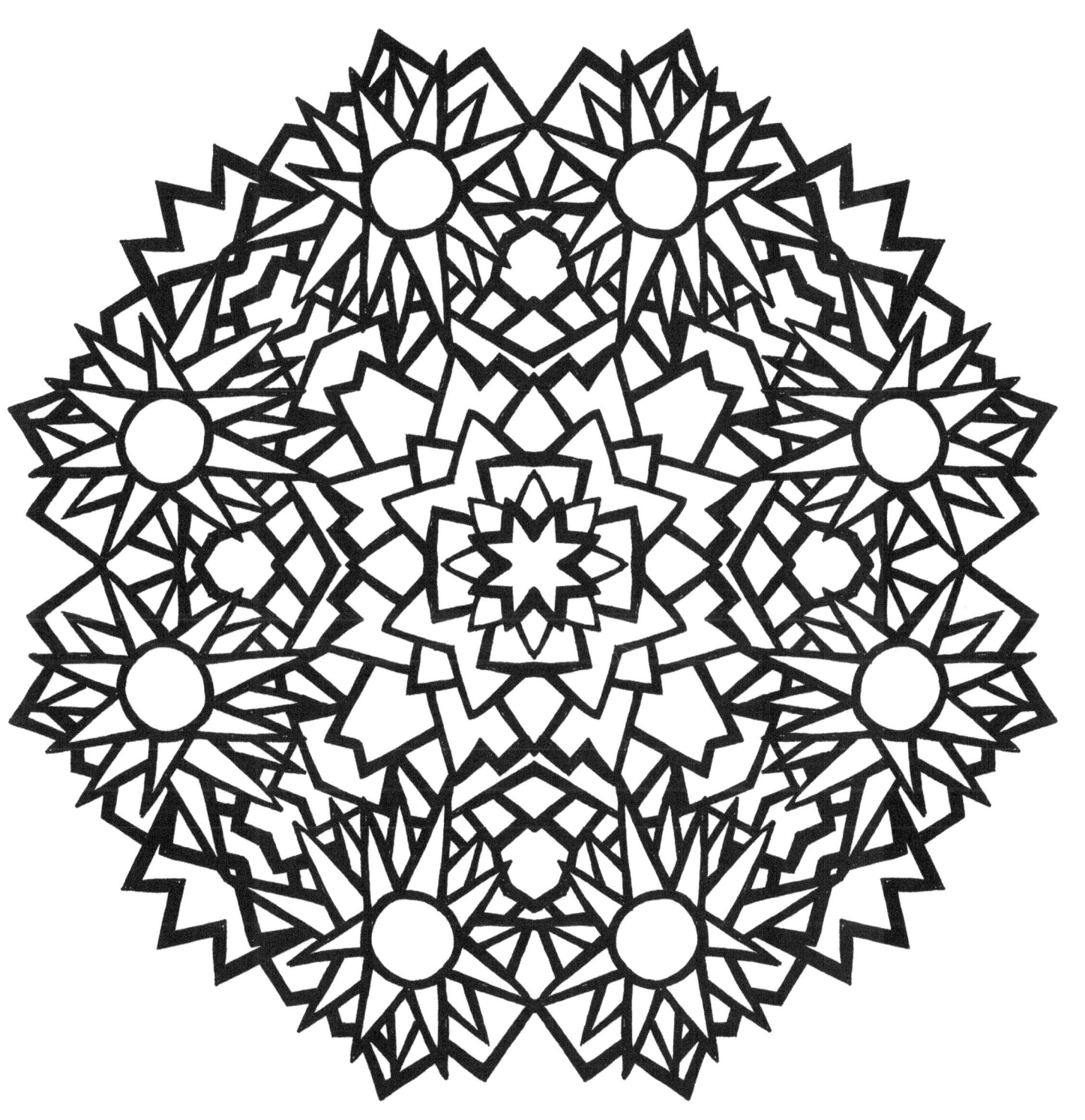

Kaleidoscopics Book 2
"Flower Box"

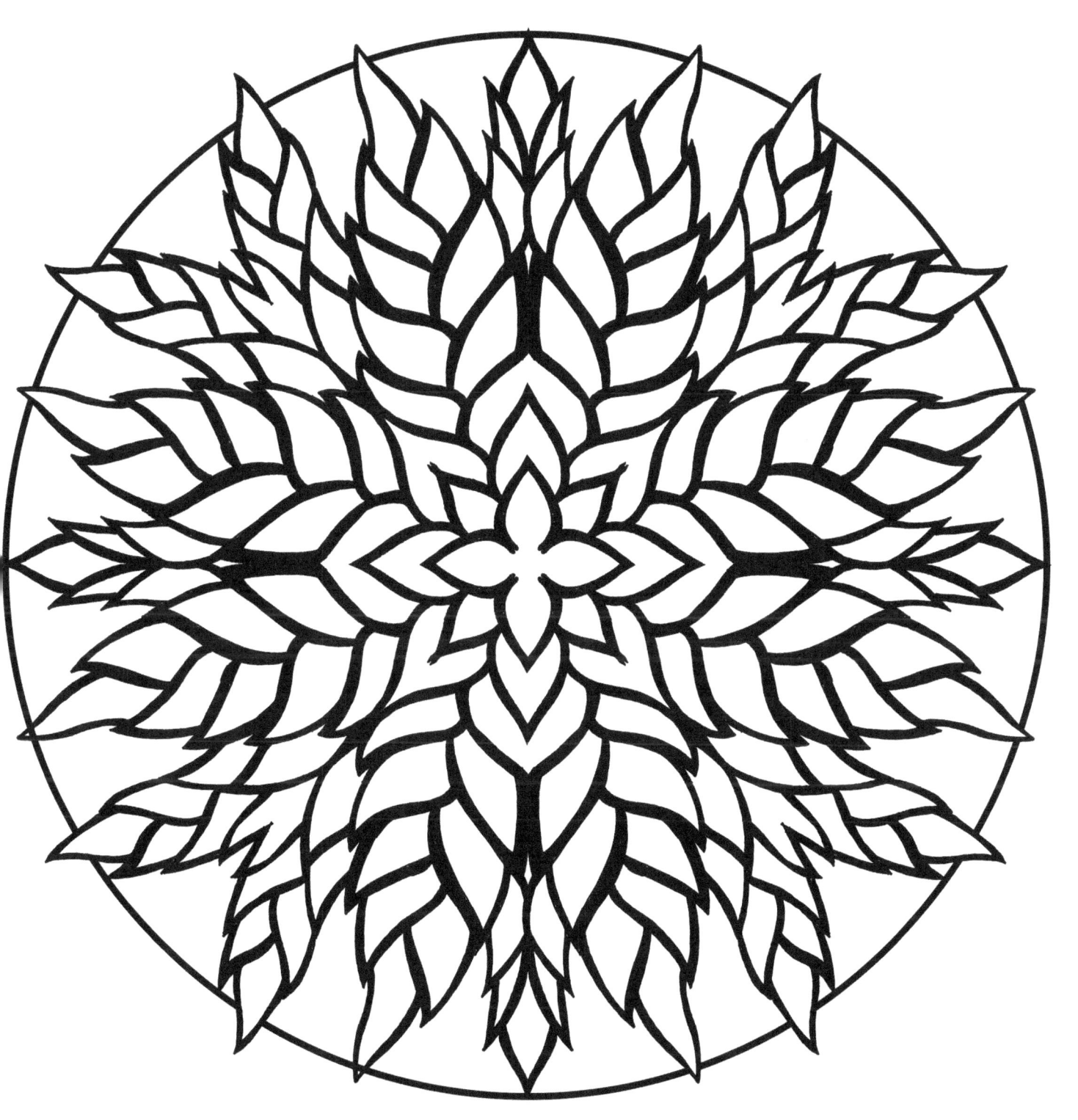

Kaleidoscopics Book 2
"Amber Waves"

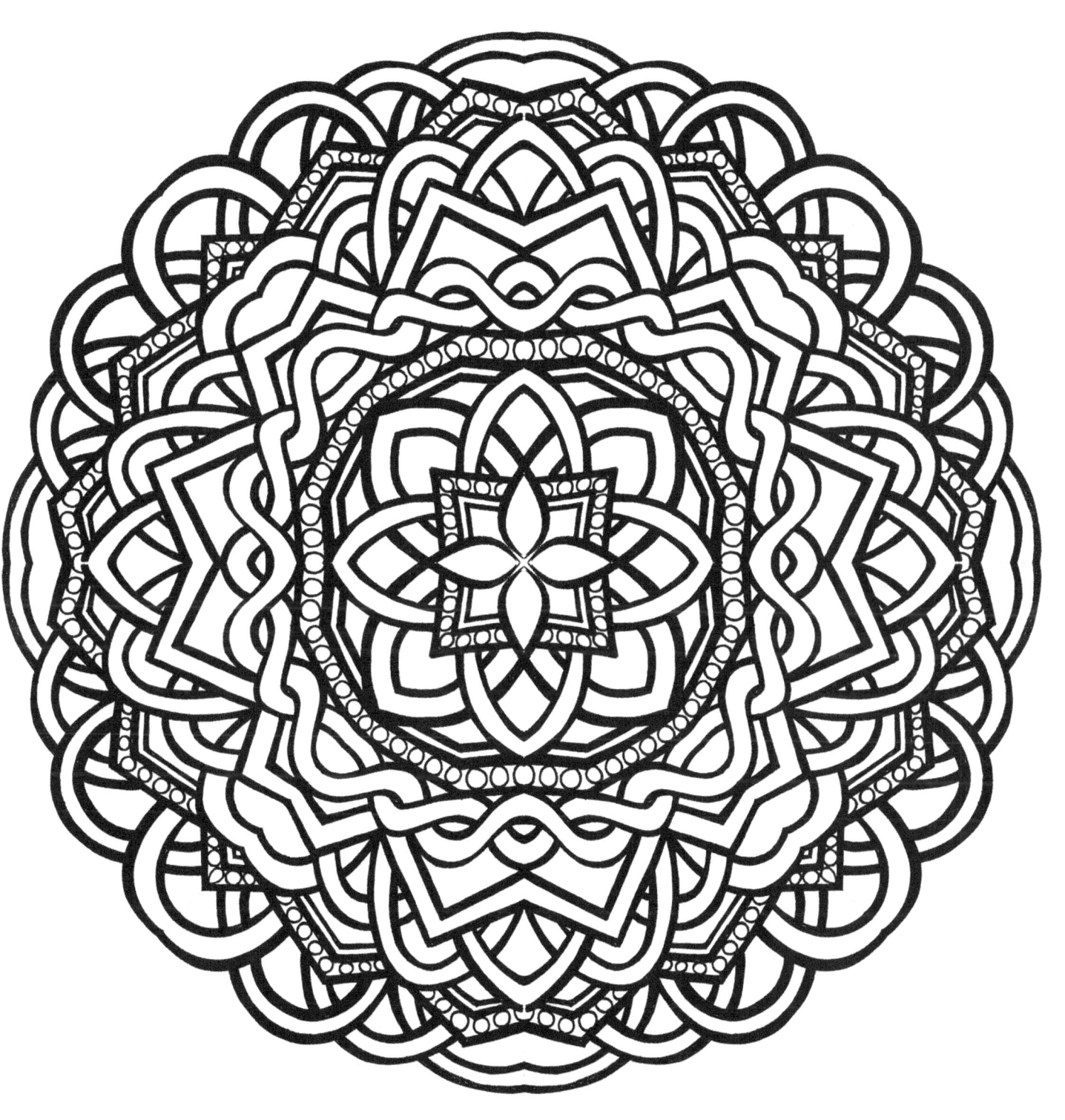

Kaleidoscopics Book 2
"Marquis Arch"

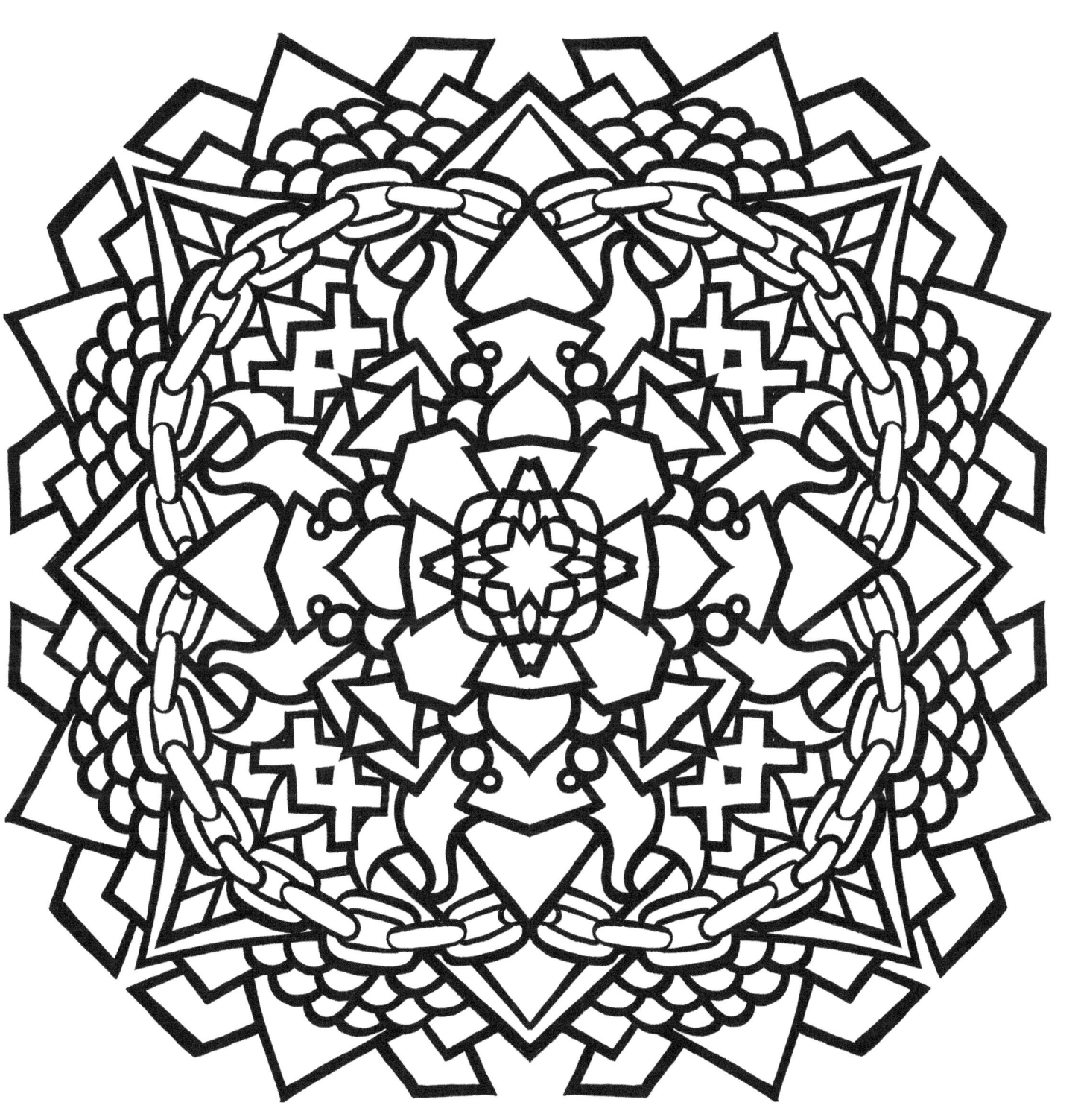

Kaleidoscopics Book 2
"Chained Melody"

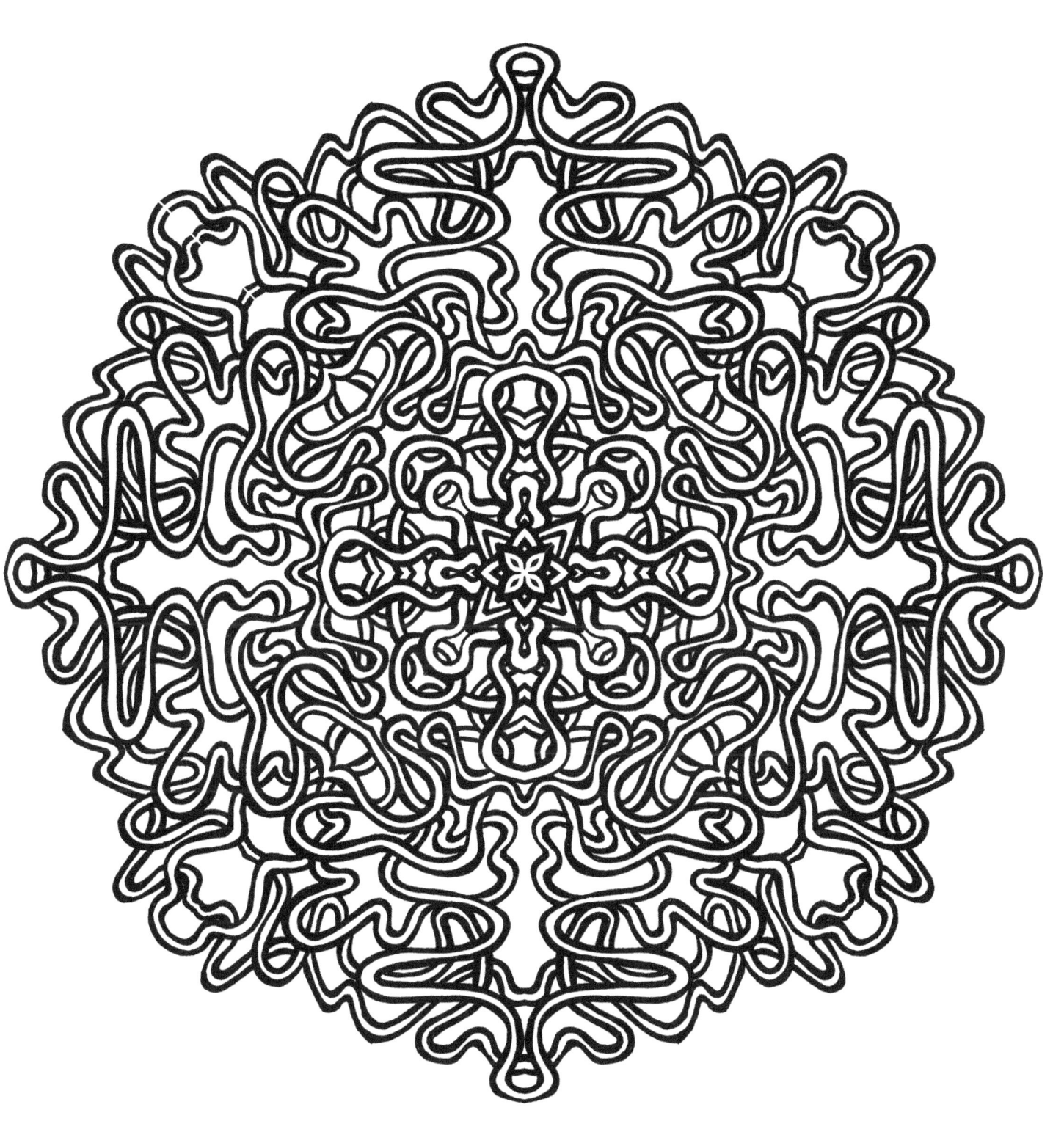

Kaleidoscopics Book 2
"Rubber Banded"

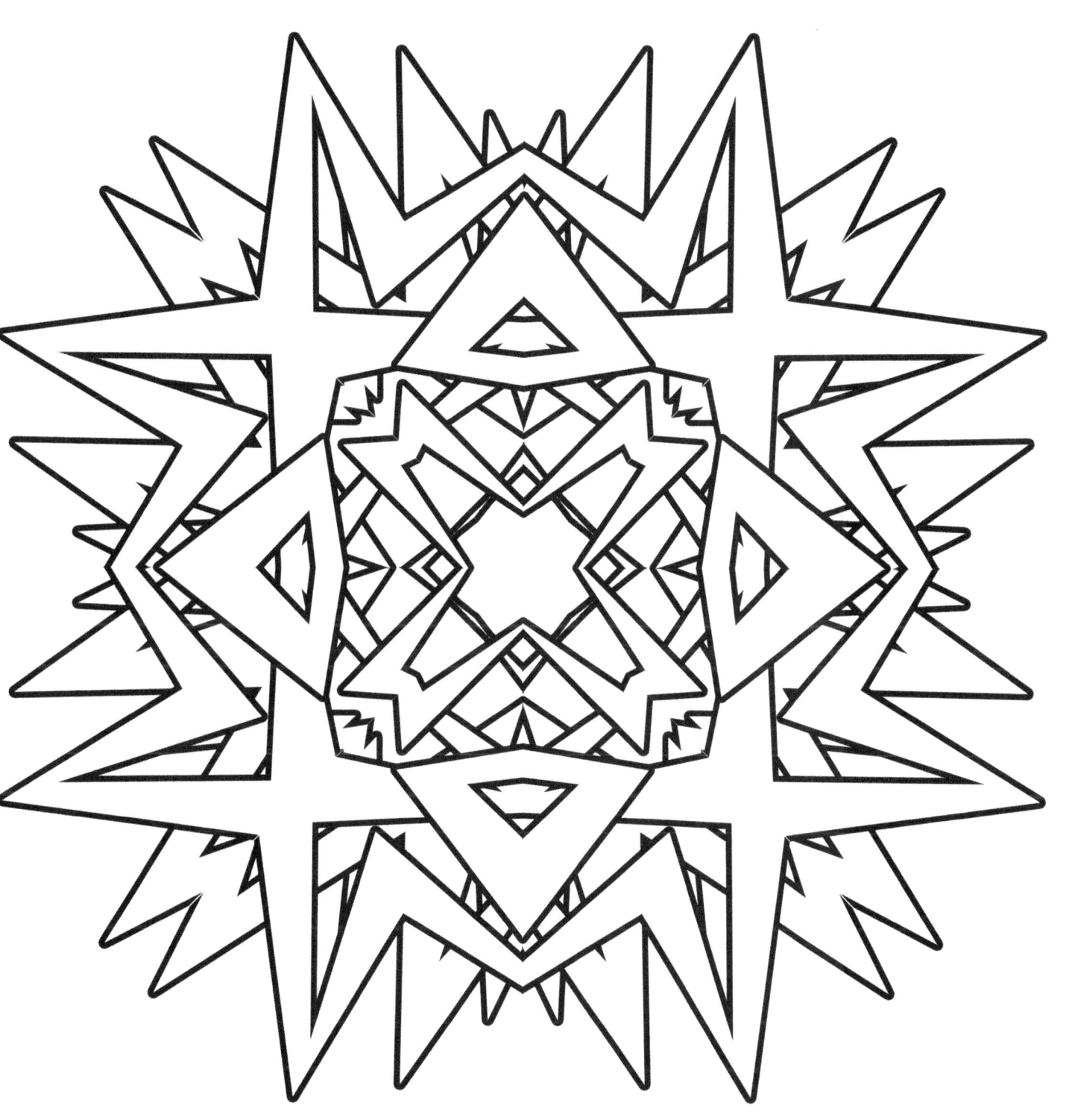

Kaleidoscopics Book 2
"Angular Mayhem"

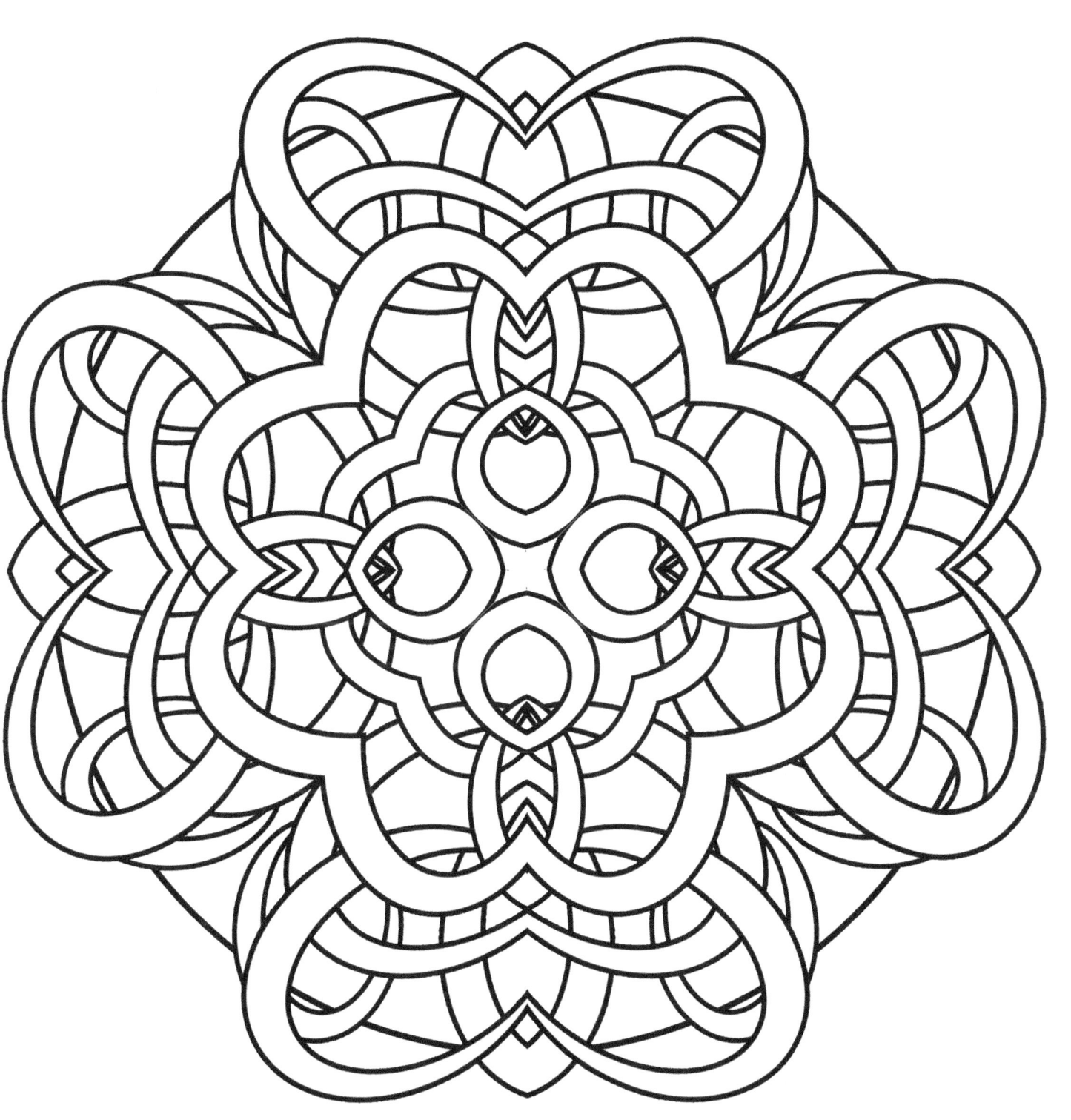

Kaleidoscopics Book 2
"Arcing"

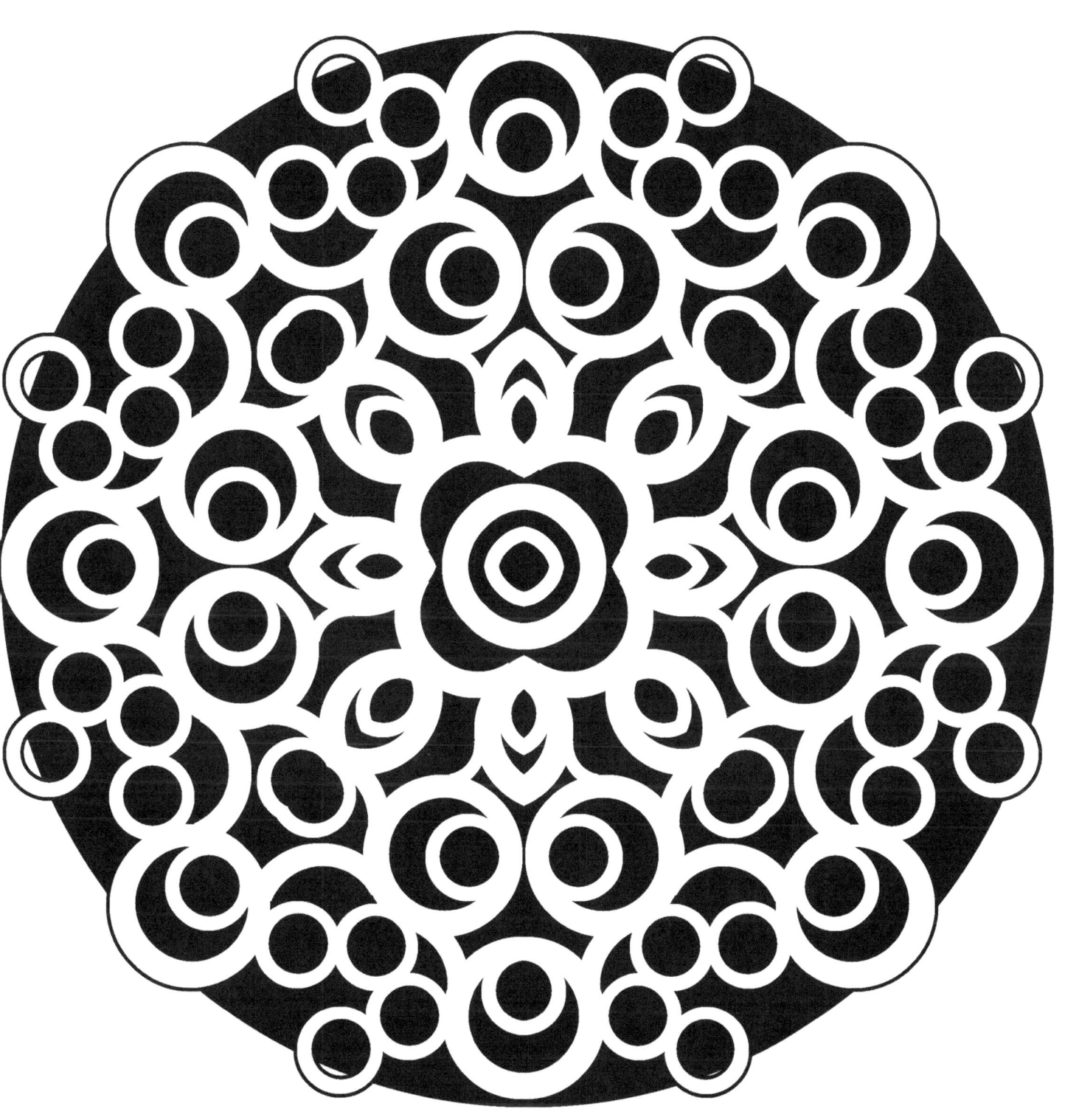

Kaleidoscopics Book 2
"Black Lace"

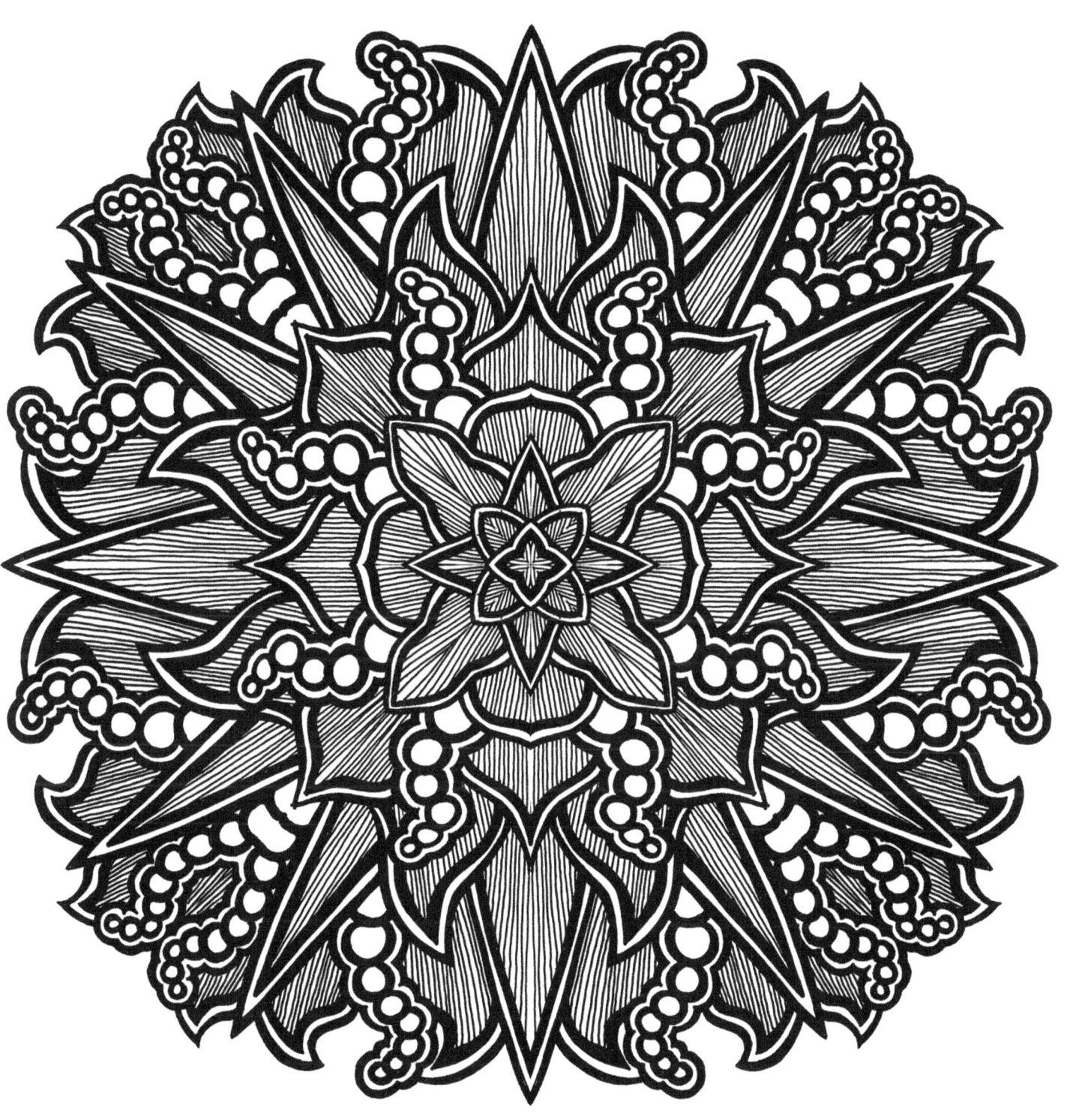

Kaleidoscopics Book 2
"Bubble Flower"

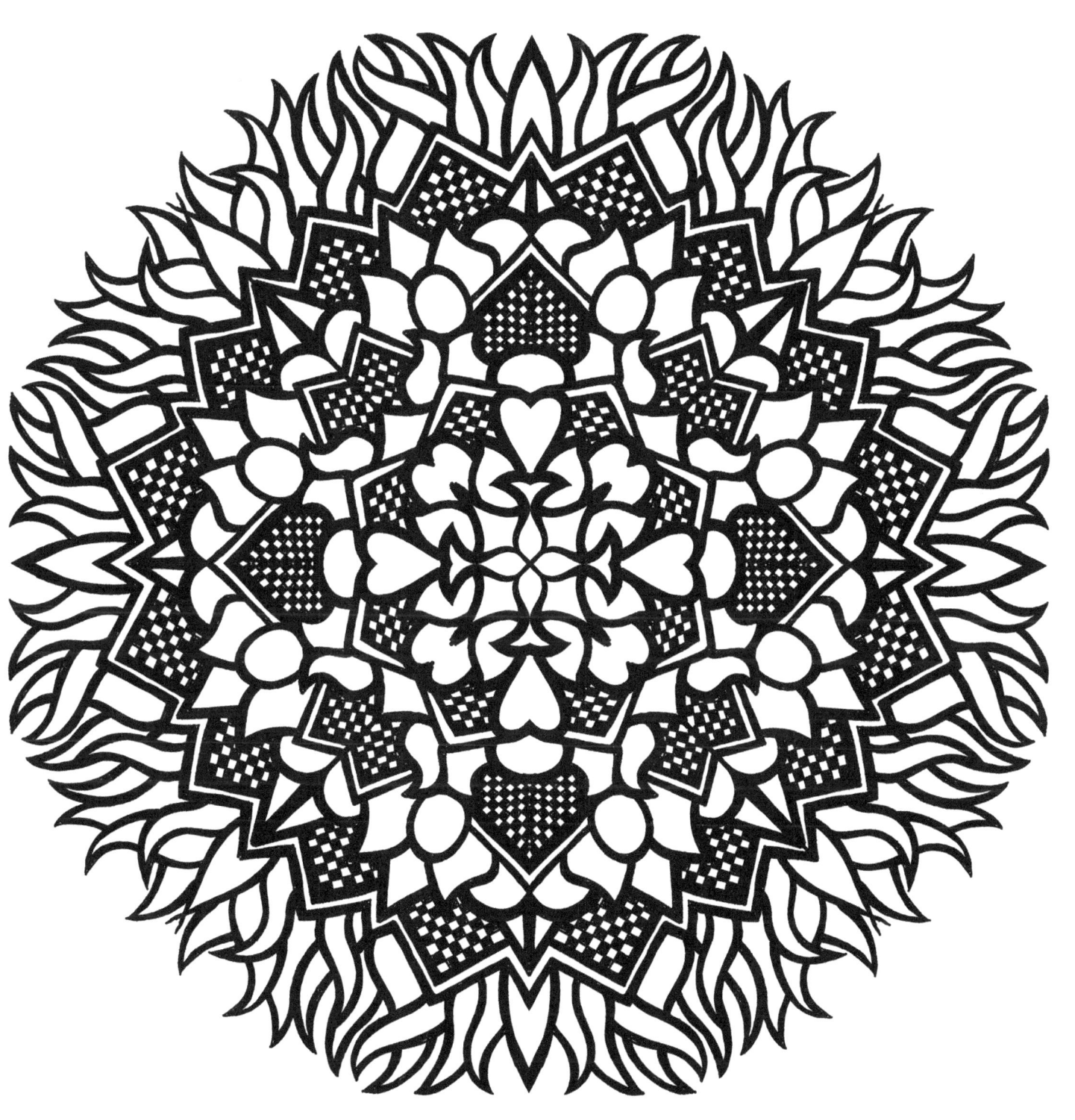

Kaleidoscopics Book 2
"Checker Flower"

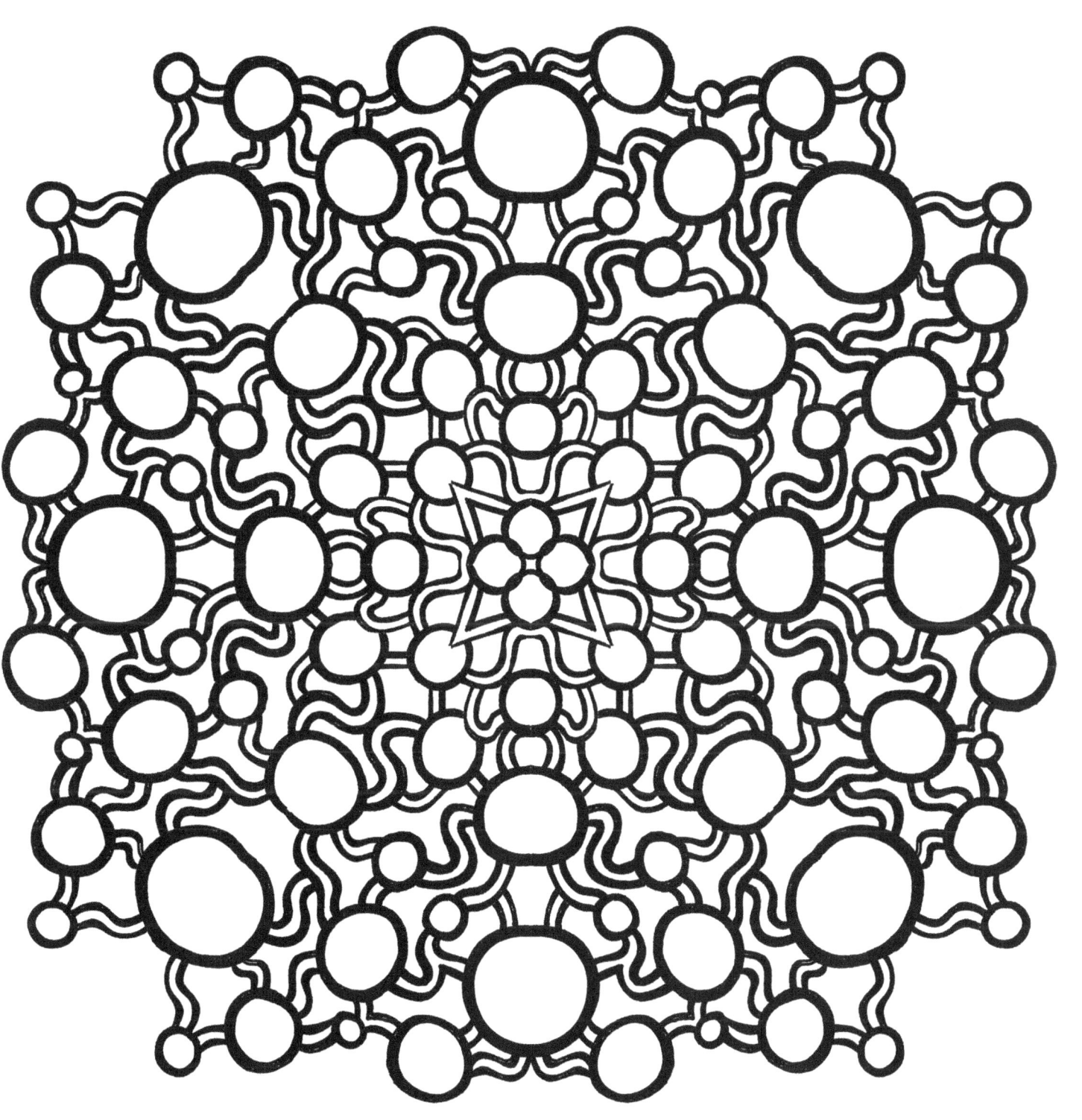

Kaleidoscopics Book 2
"Hampster Paradise"

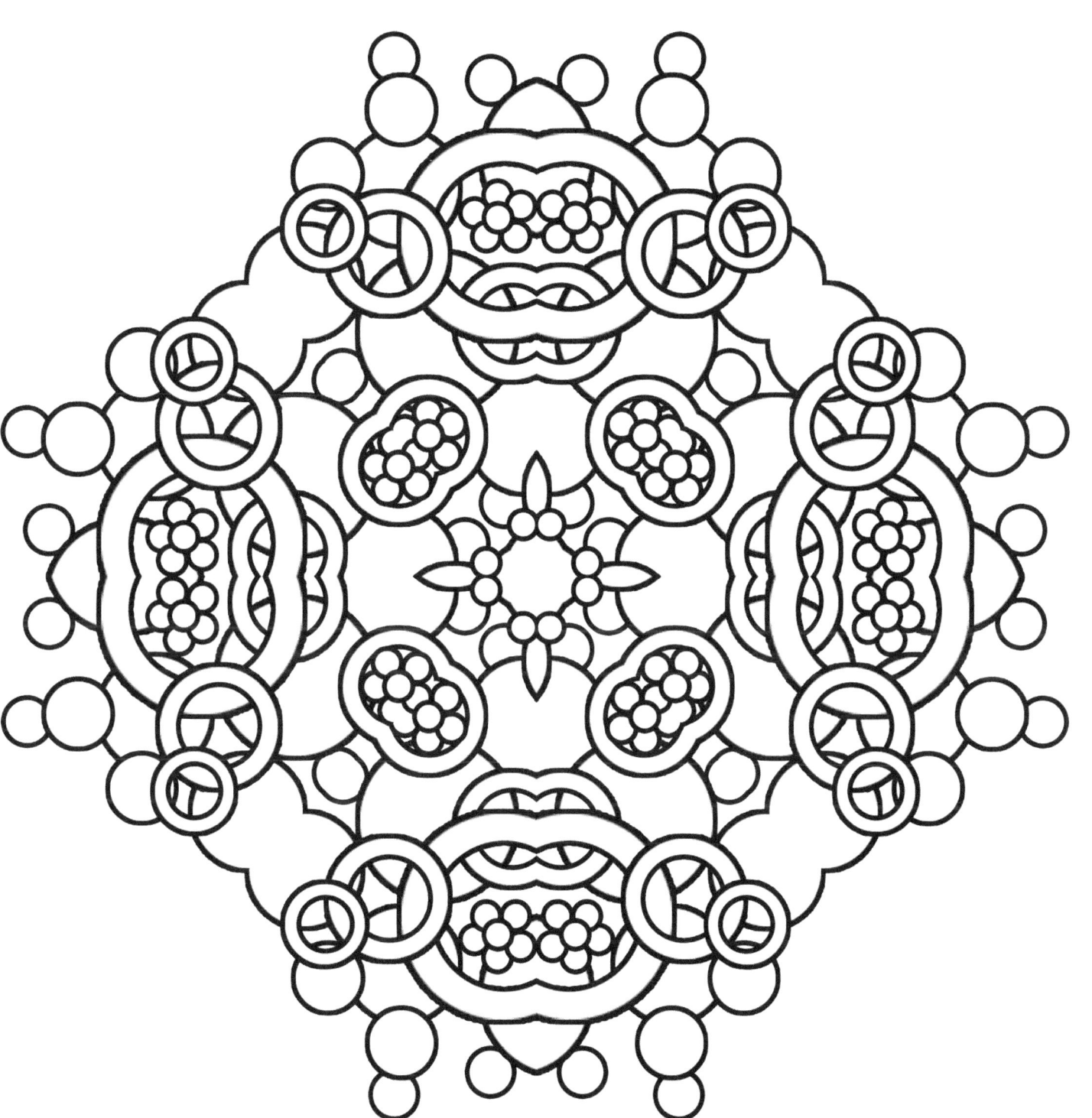

Kaleidoscopics Book 2
"Circular Logic"

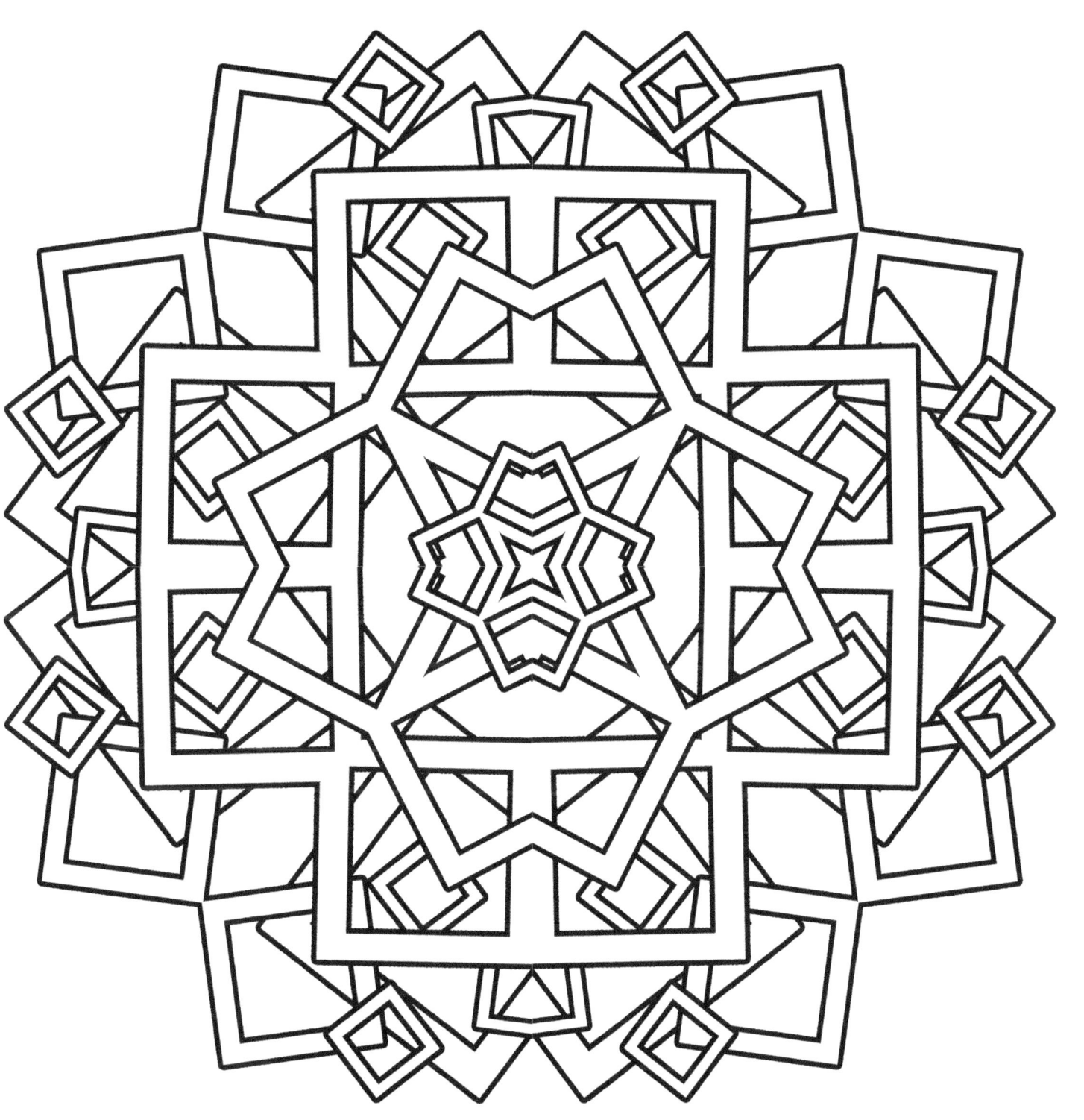

Kaleidoscopics Book 2
"Squarely Square"

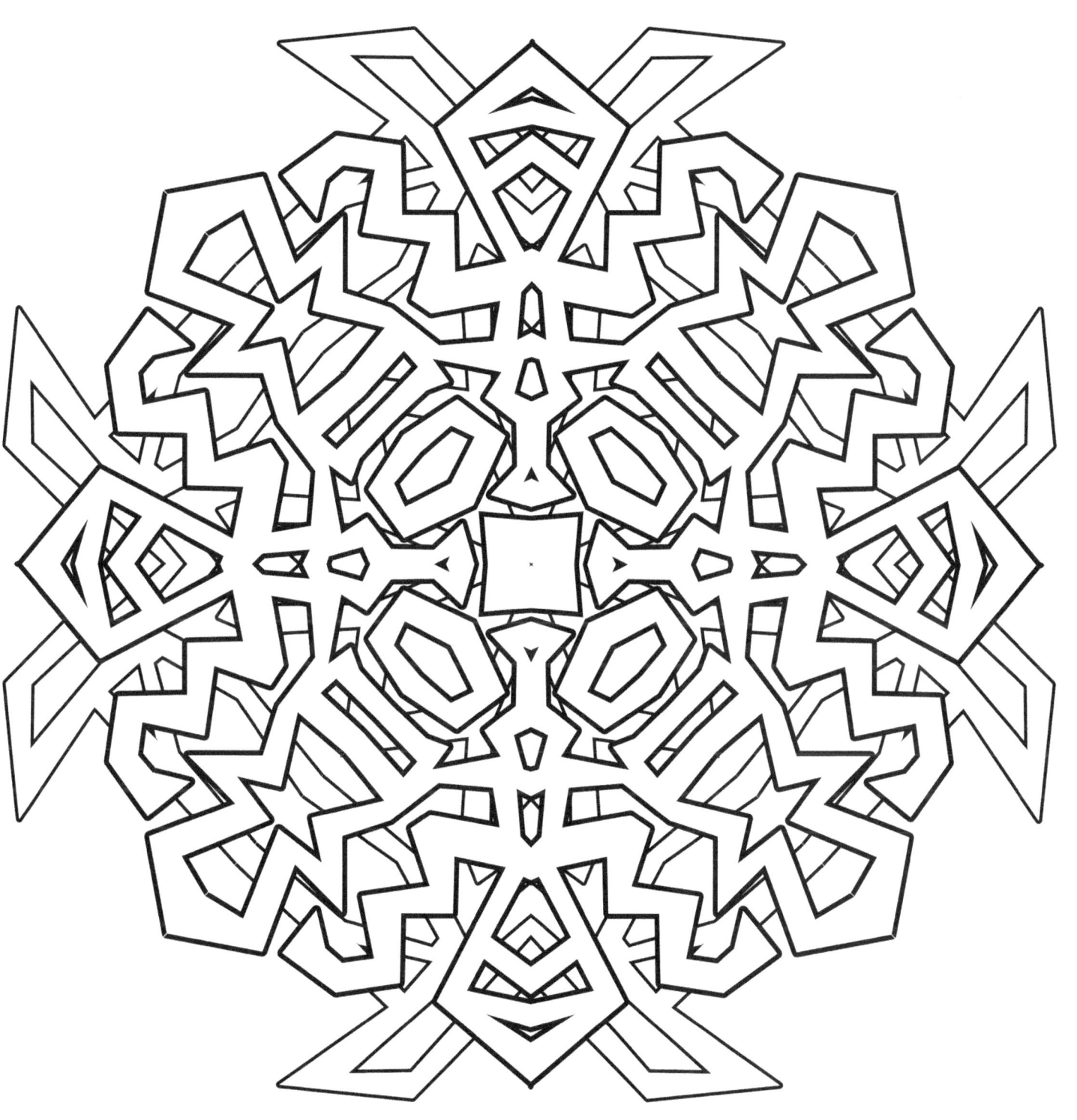

Kaleidoscopics Book 2
"Digital Mayan"

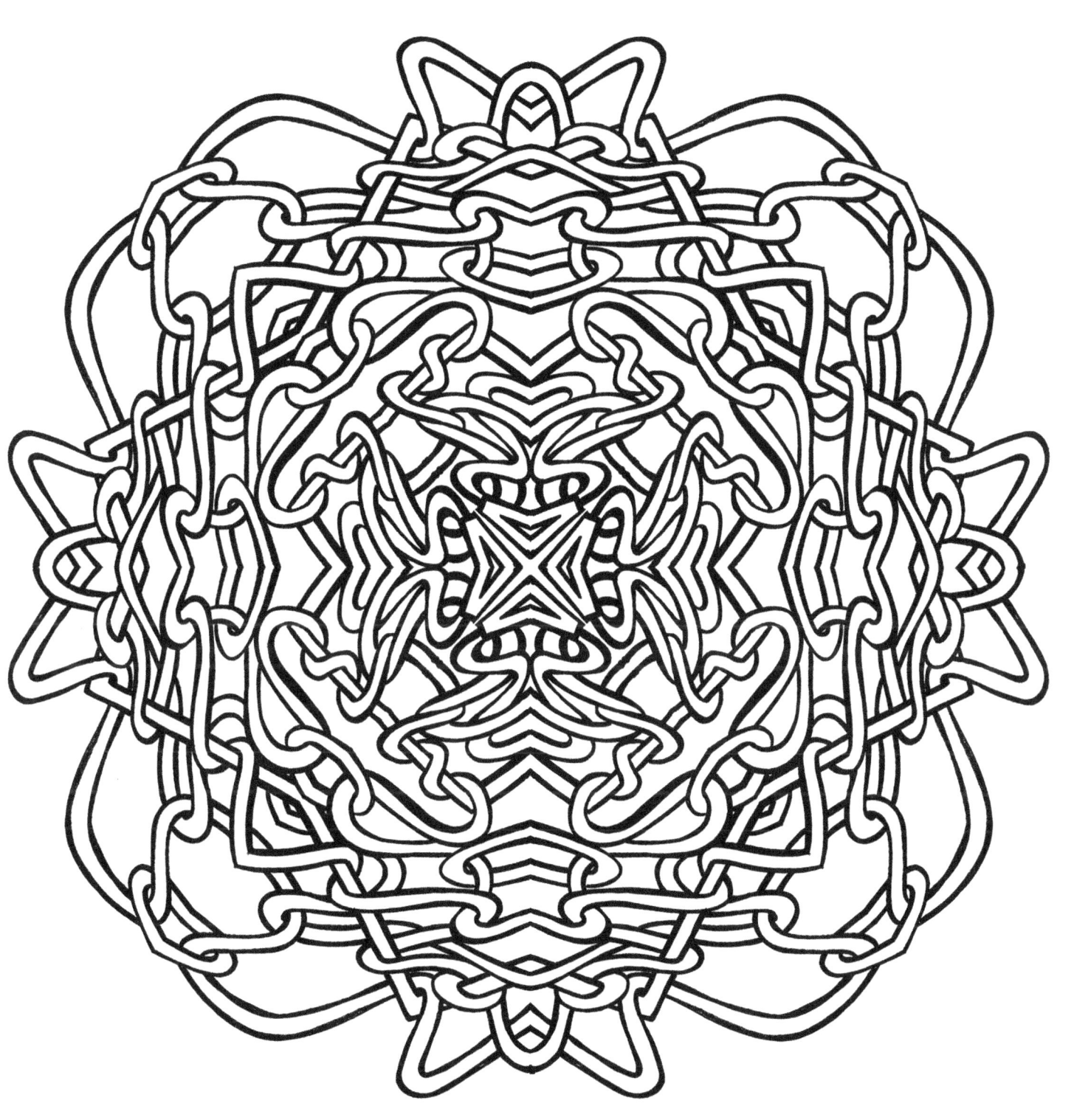

Kaleidoscopics Book 2
"Banded Together"

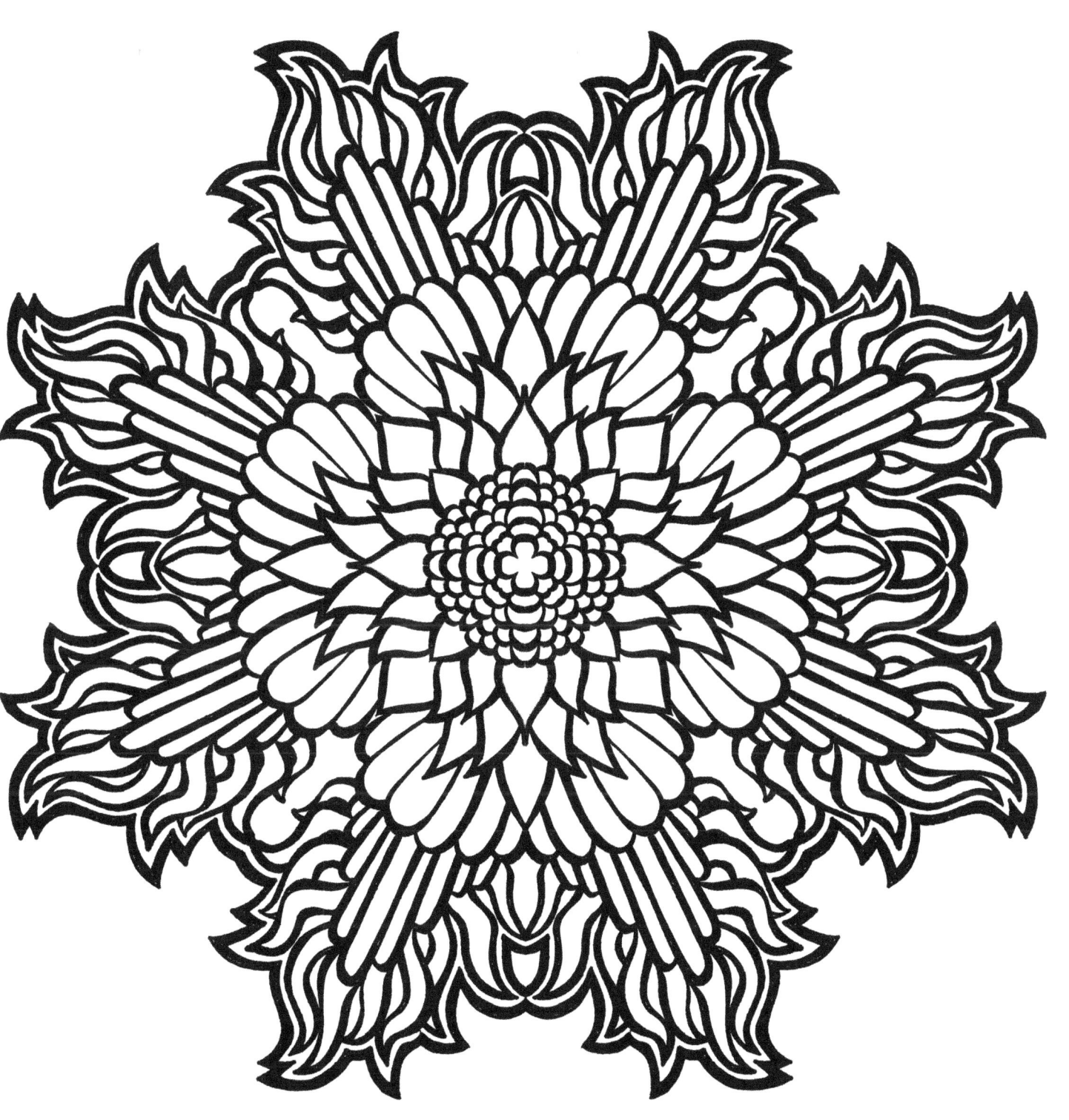

Kaleidoscopics Book 2
"Fuego Fleur"

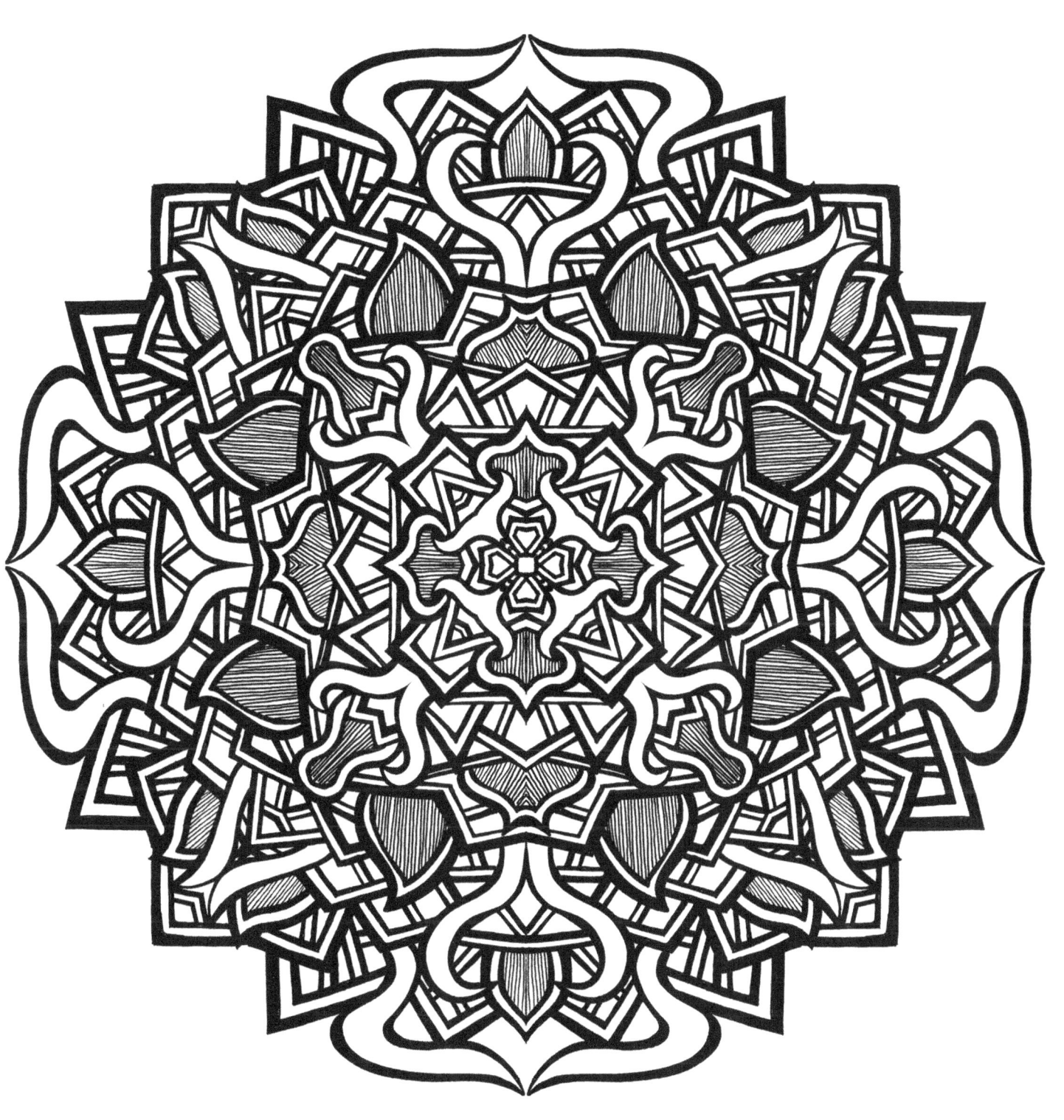

Kaleidoscopics Book 2
"Crystaline Wave"

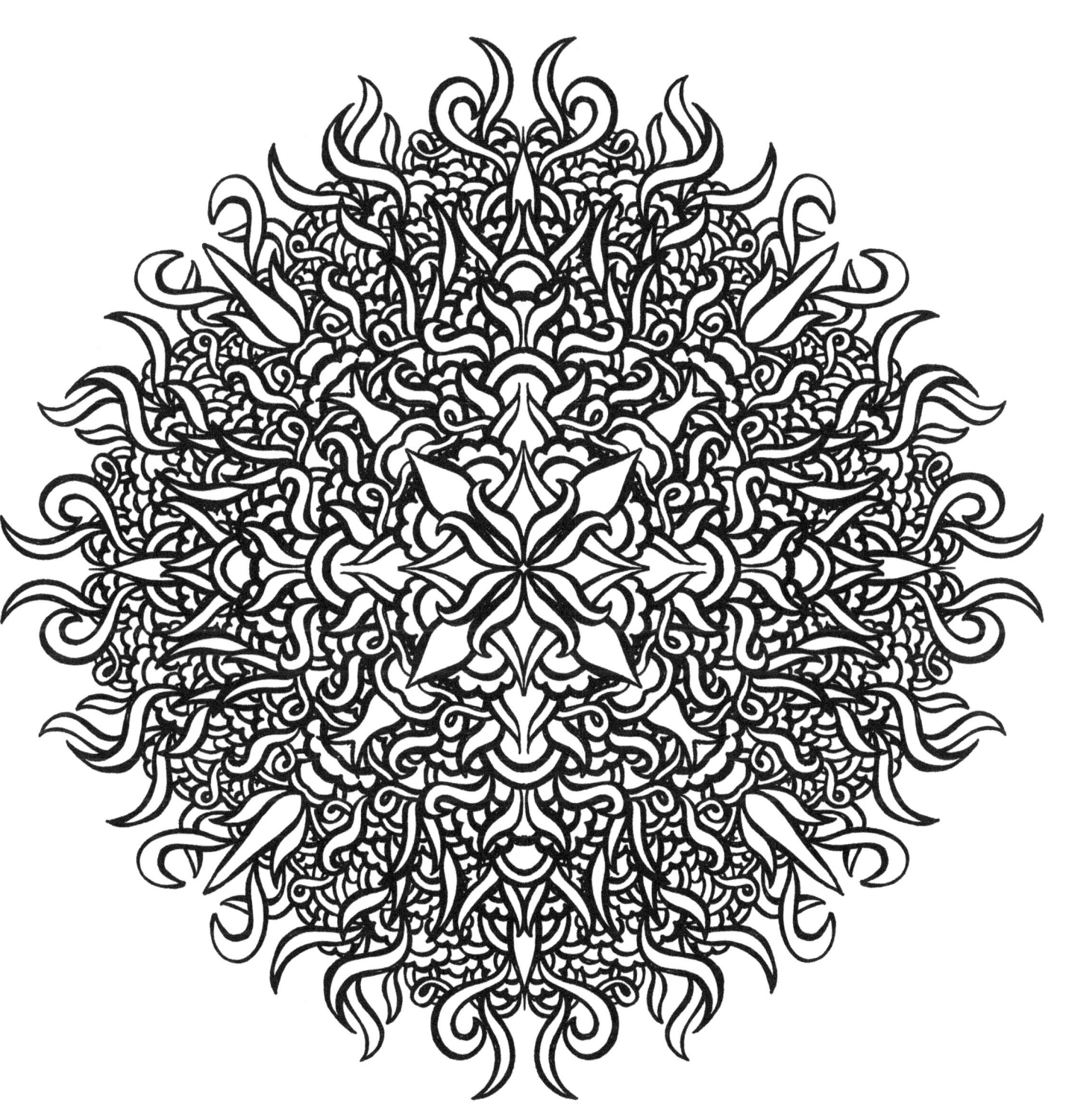

Kaleidoscopics Book 2
"Floral Mayhem"

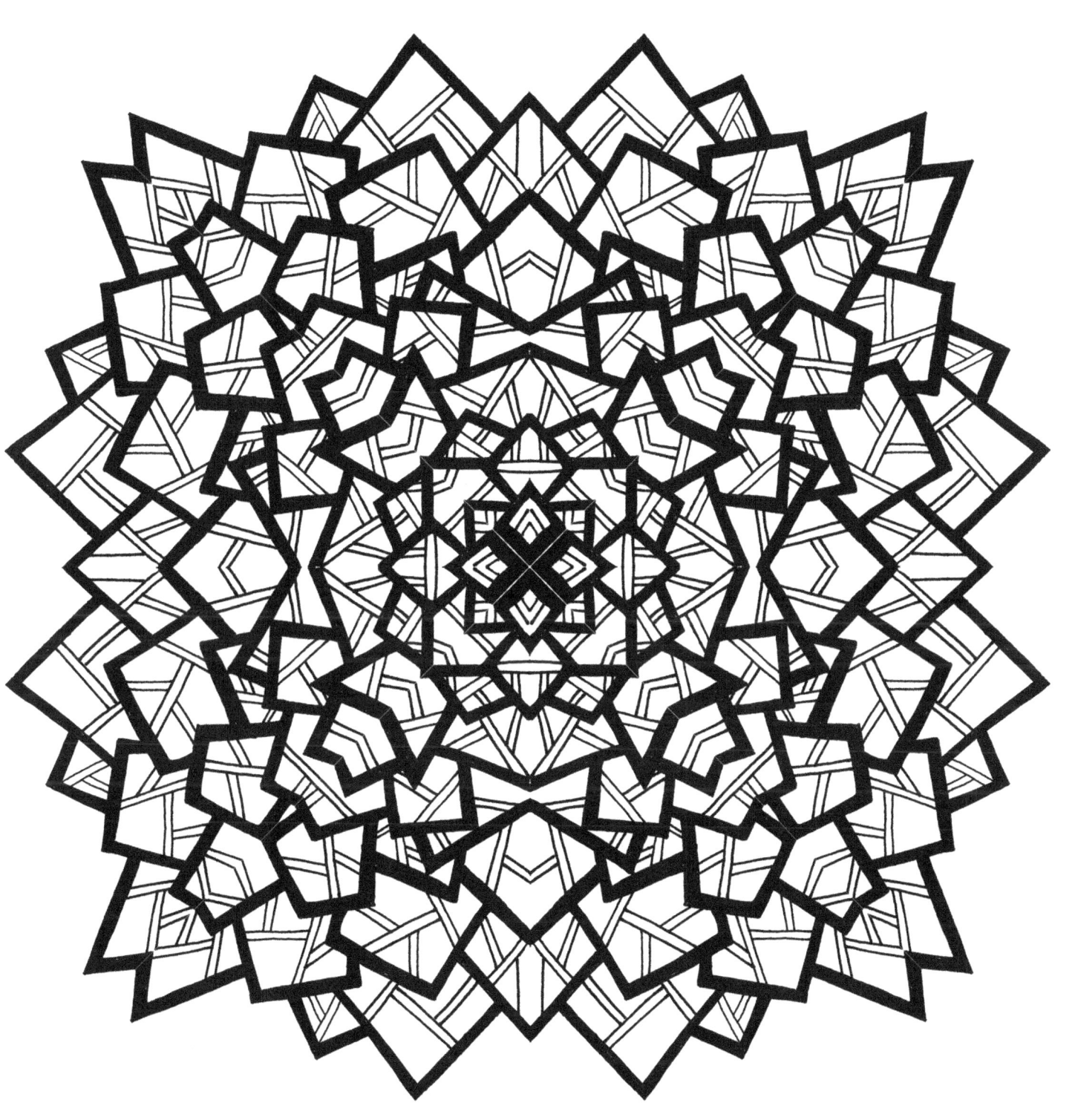

Kaleidoscopics Book 2
"Fractal Fantasy"

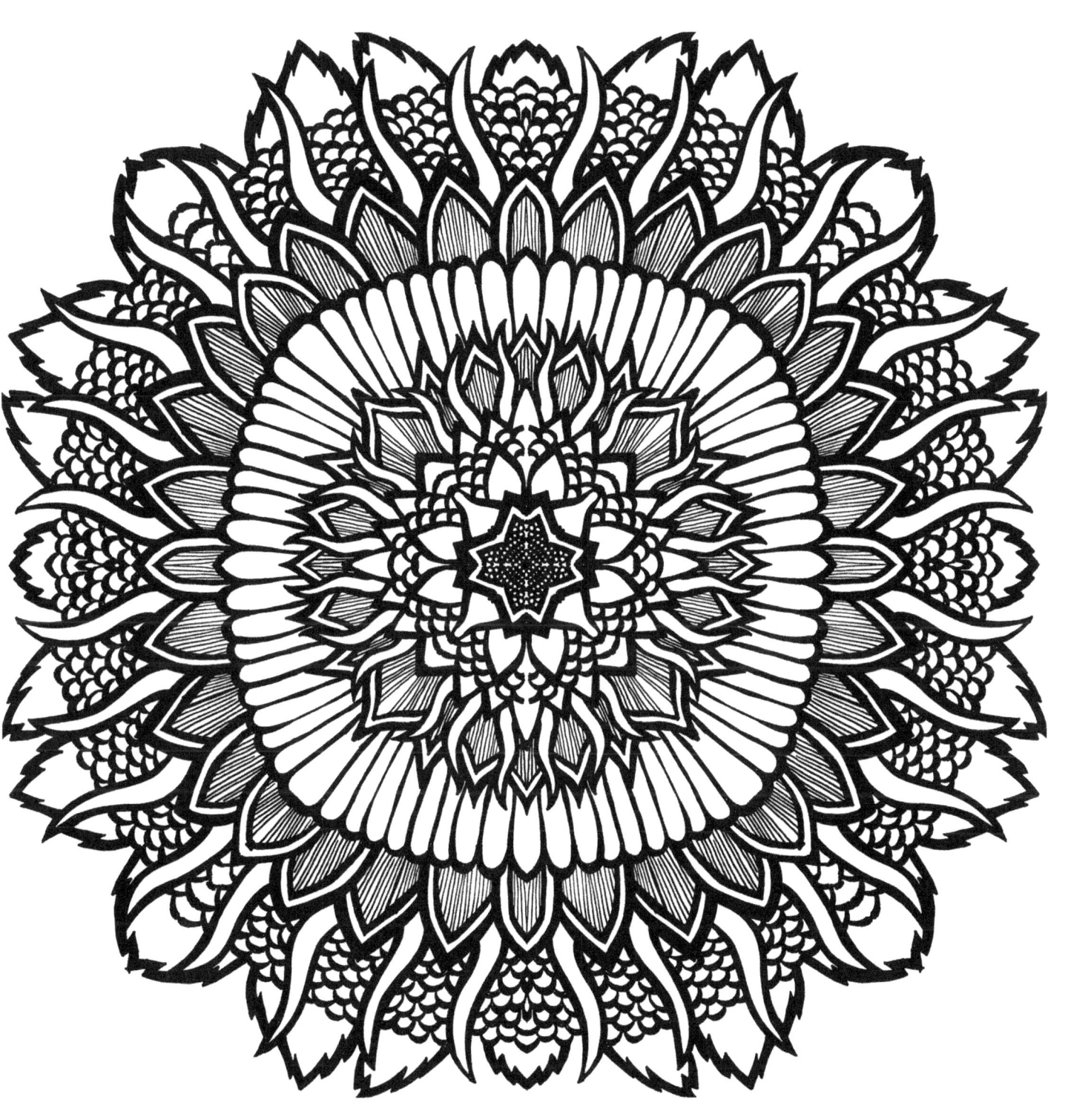

Kaleidoscopics Book 2
"Kale-A-Flower"

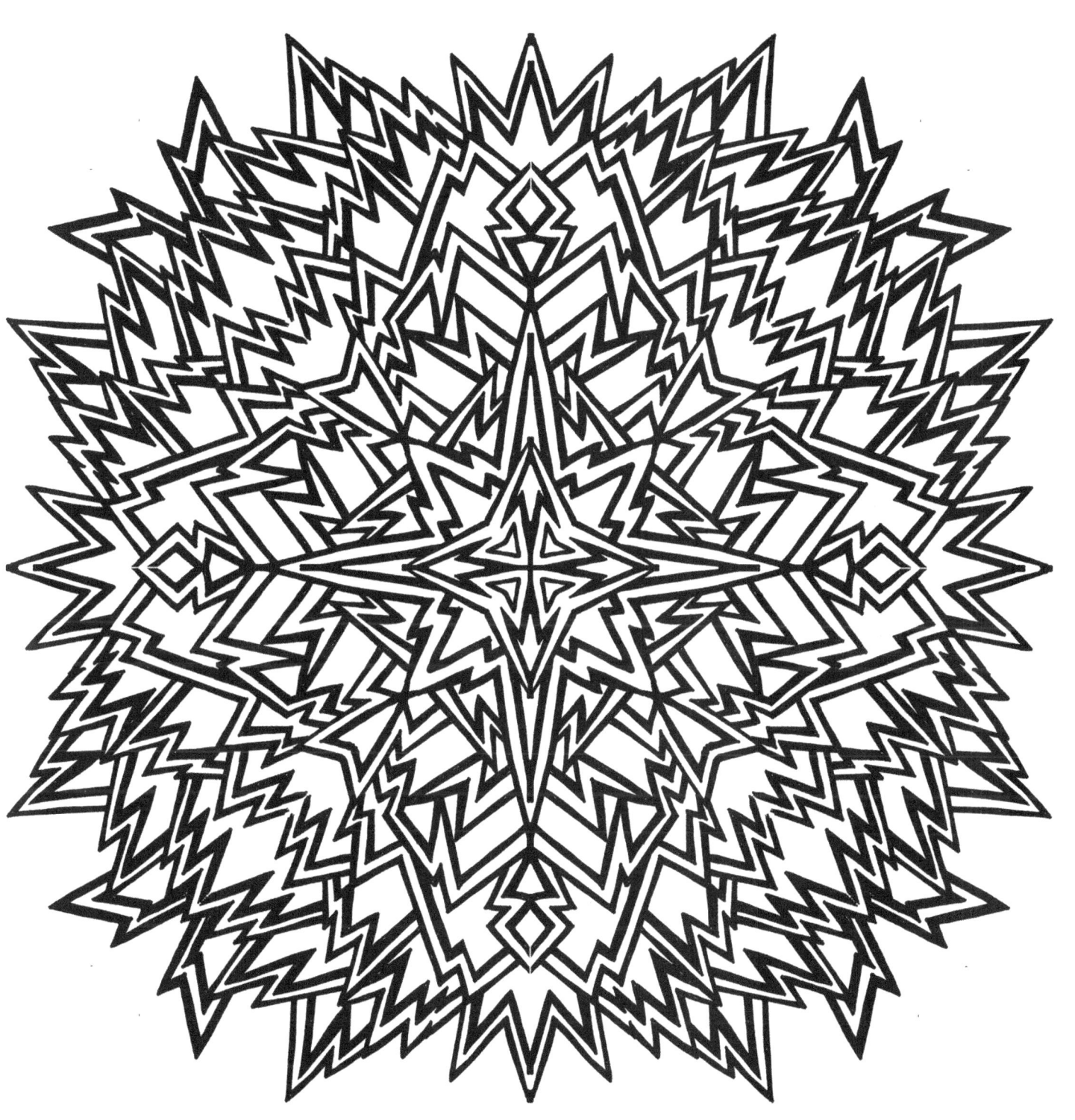

Kaleidoscopics Book 2
"Zapped"

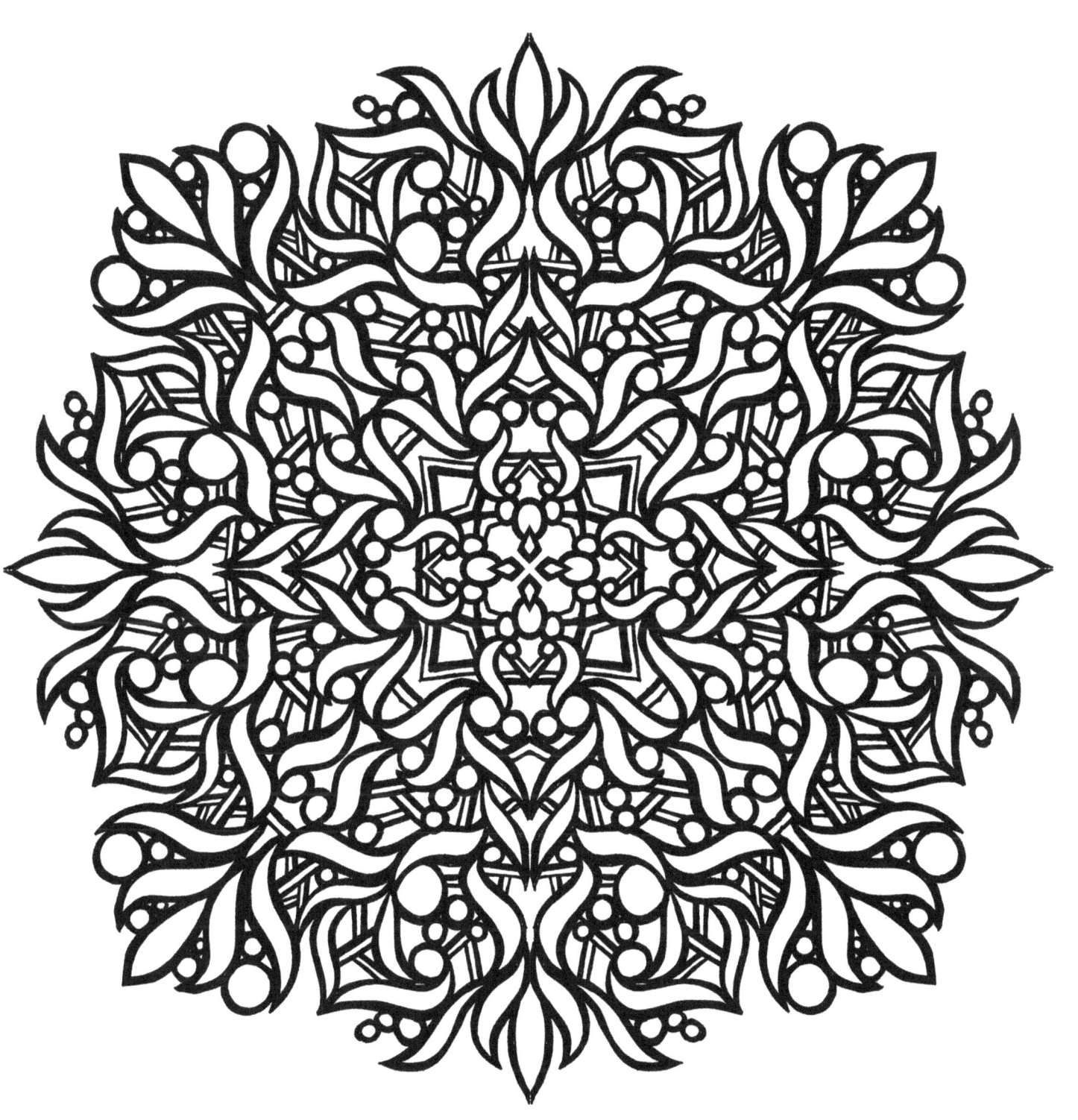

Kaleidoscopics Book 2
"Berry Berry"

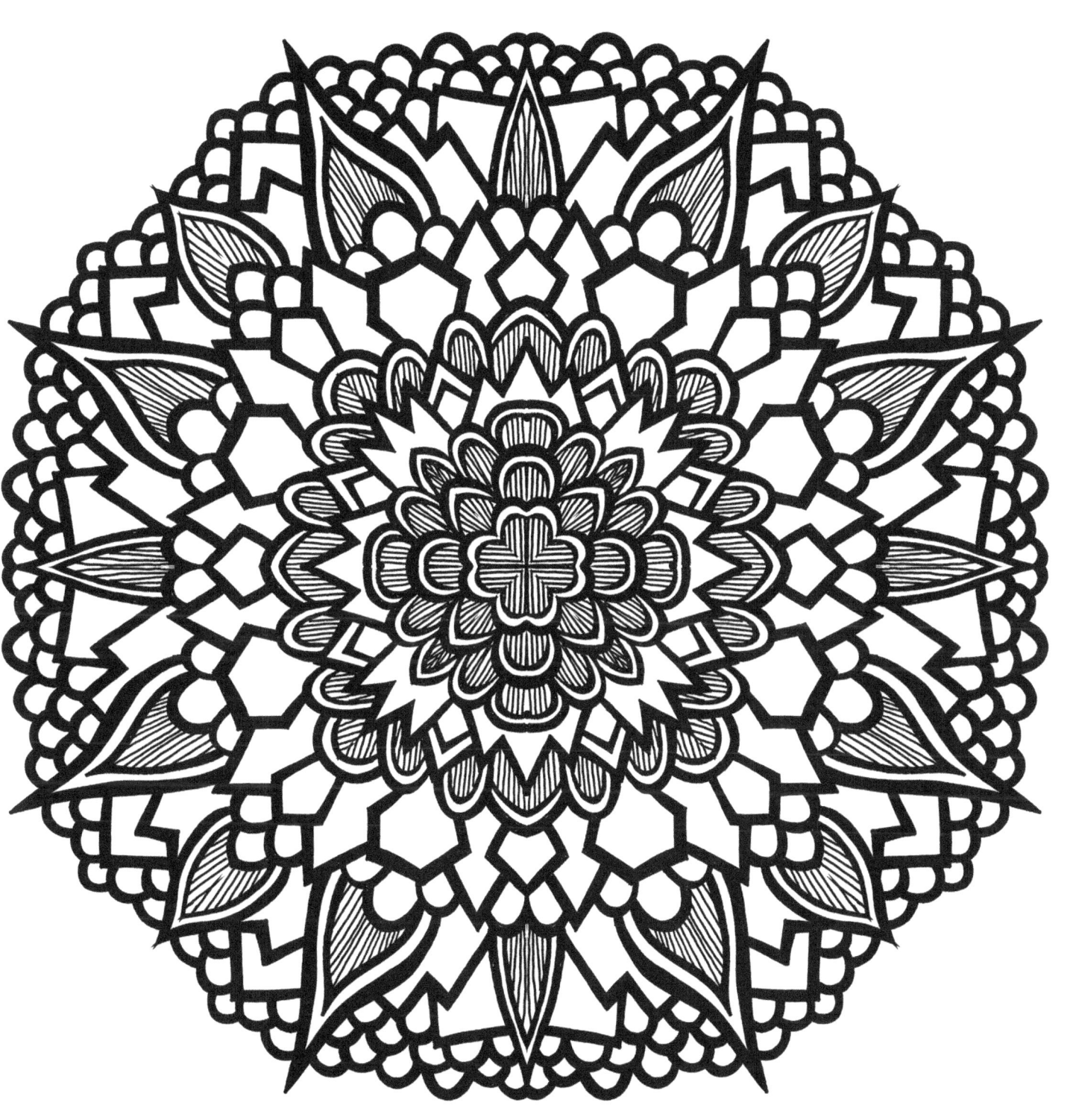

Kaleidoscopics Book 2
"Made In the Shading"

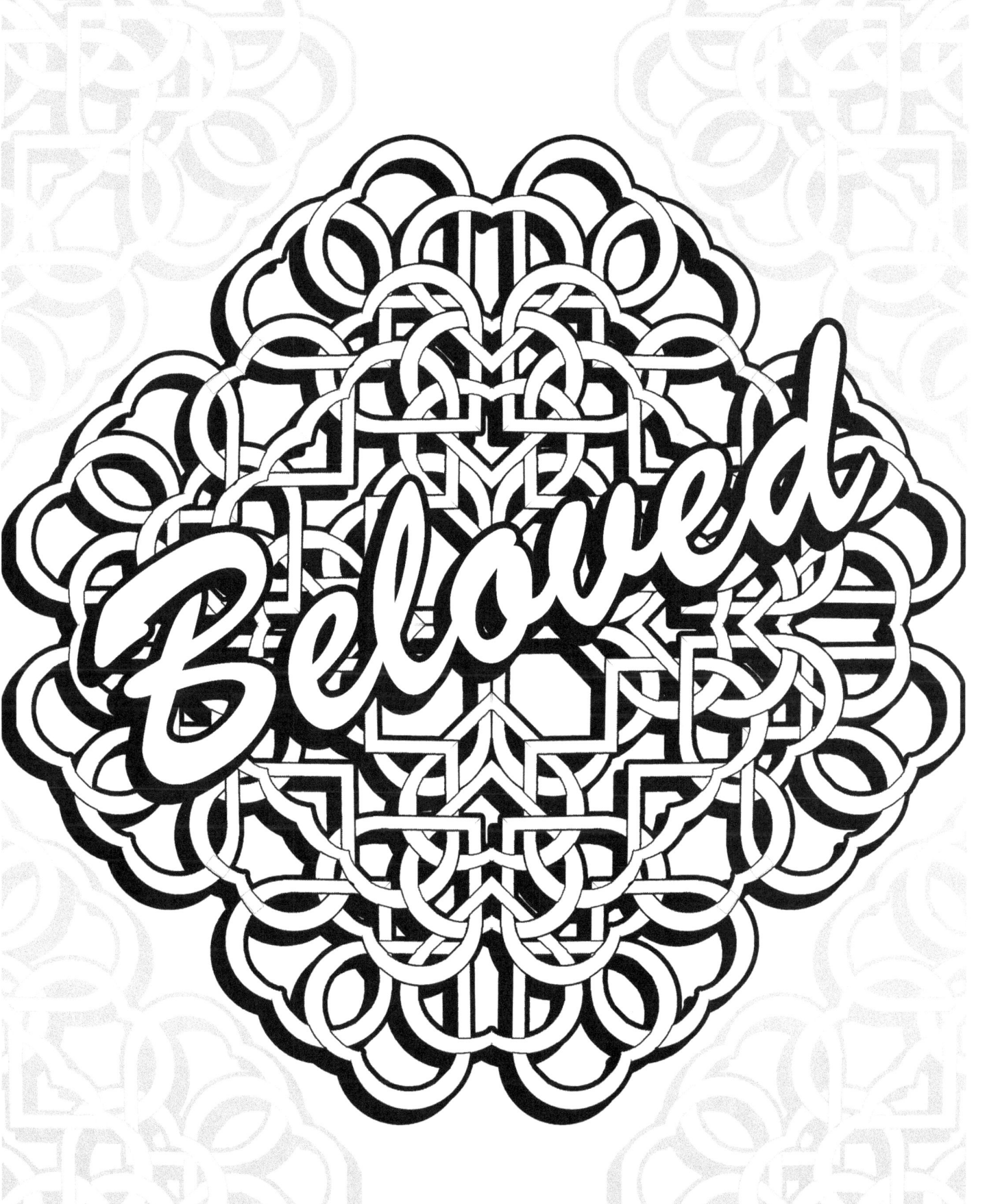

Kaleidoscopics Book 2
"Beloved"

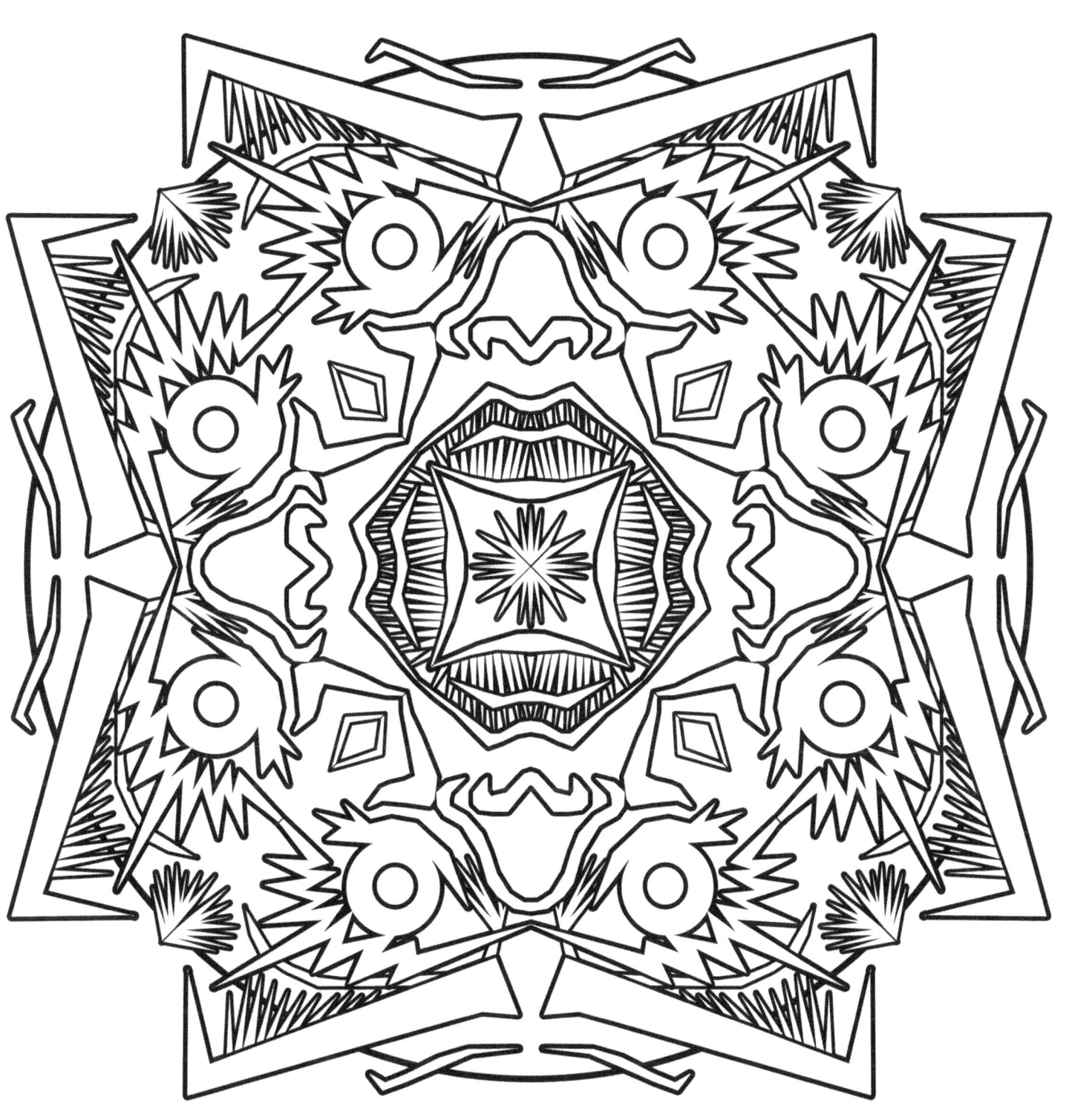

Kaleidoscopics Book 2
"Machine Heads"

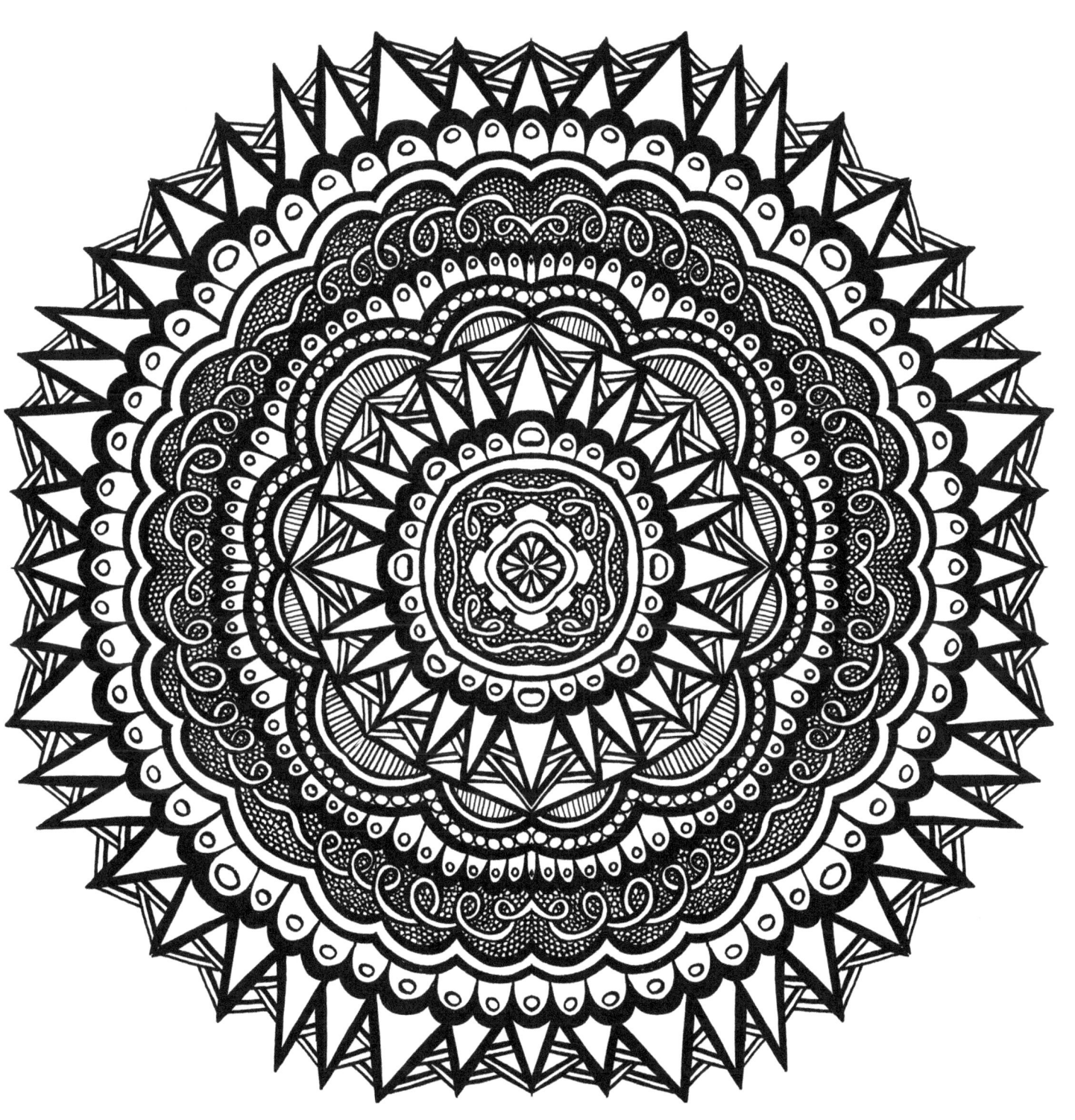

Kaleidoscopics Book 2
"Maniacala"

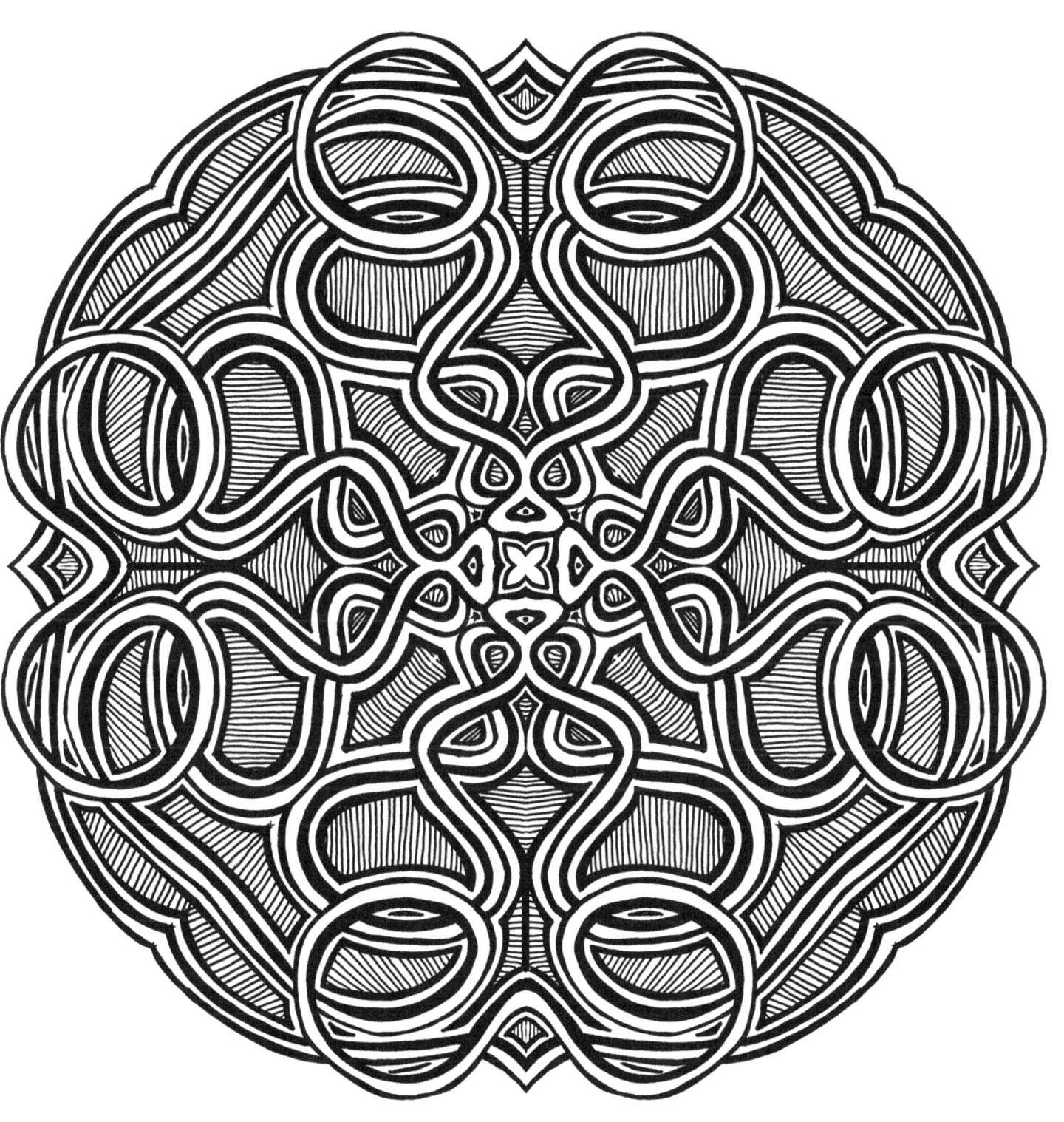

Kaleidoscopics Book 2
"Overpass"

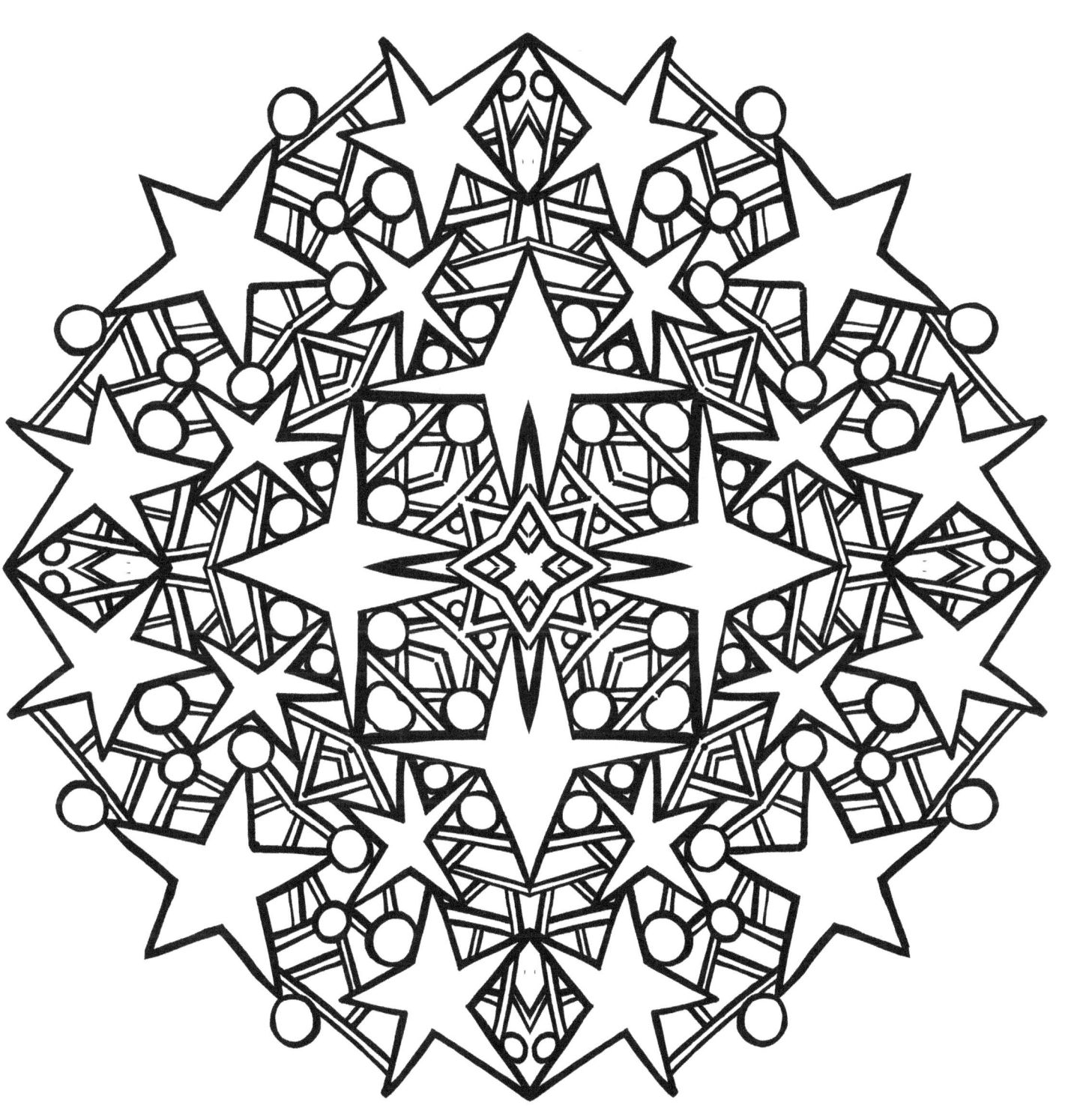

Kaleidoscopics Book 2
"Star Crossed"

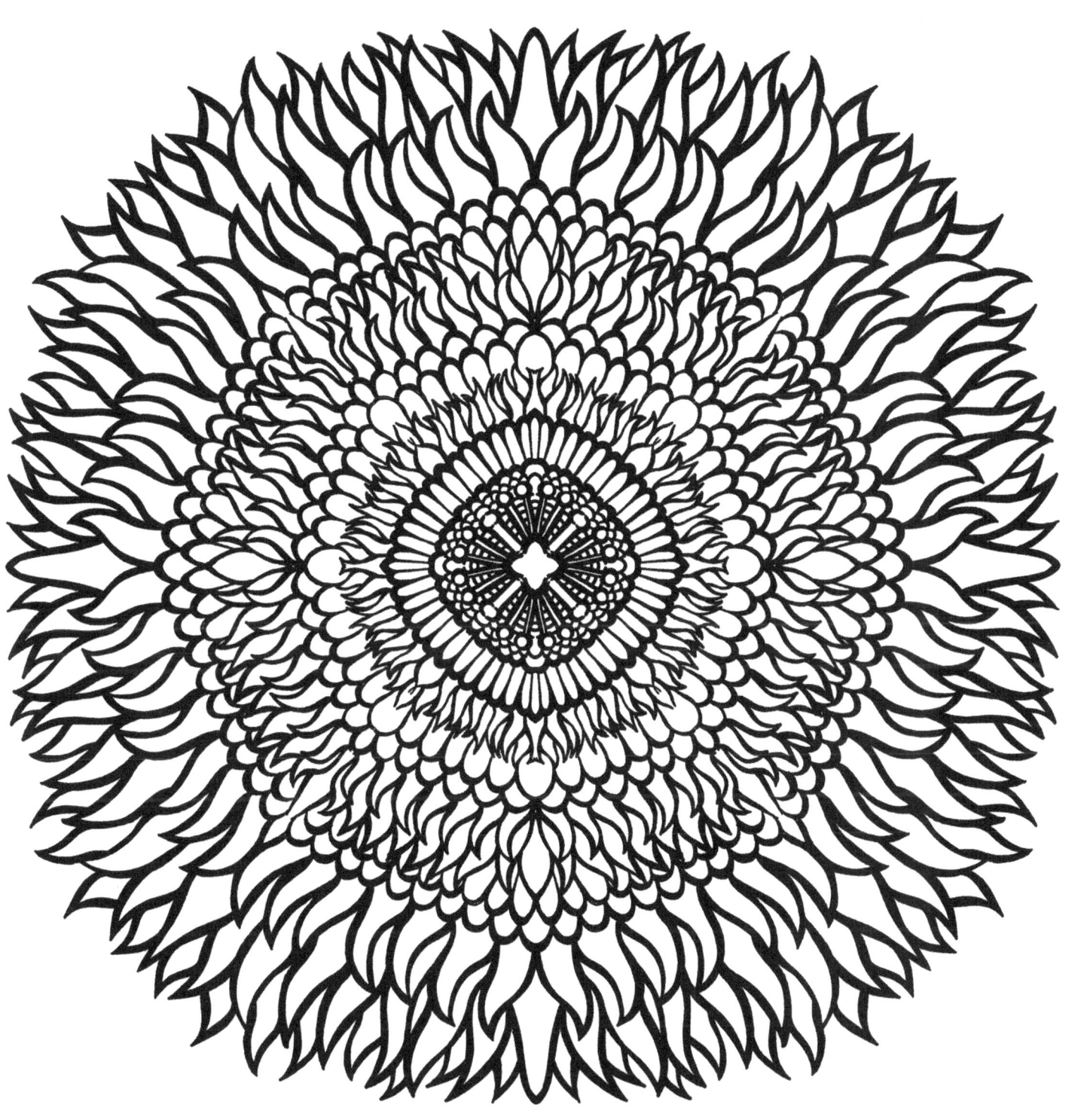

Kaleidoscopics Book 2
"Flames and Feathers"

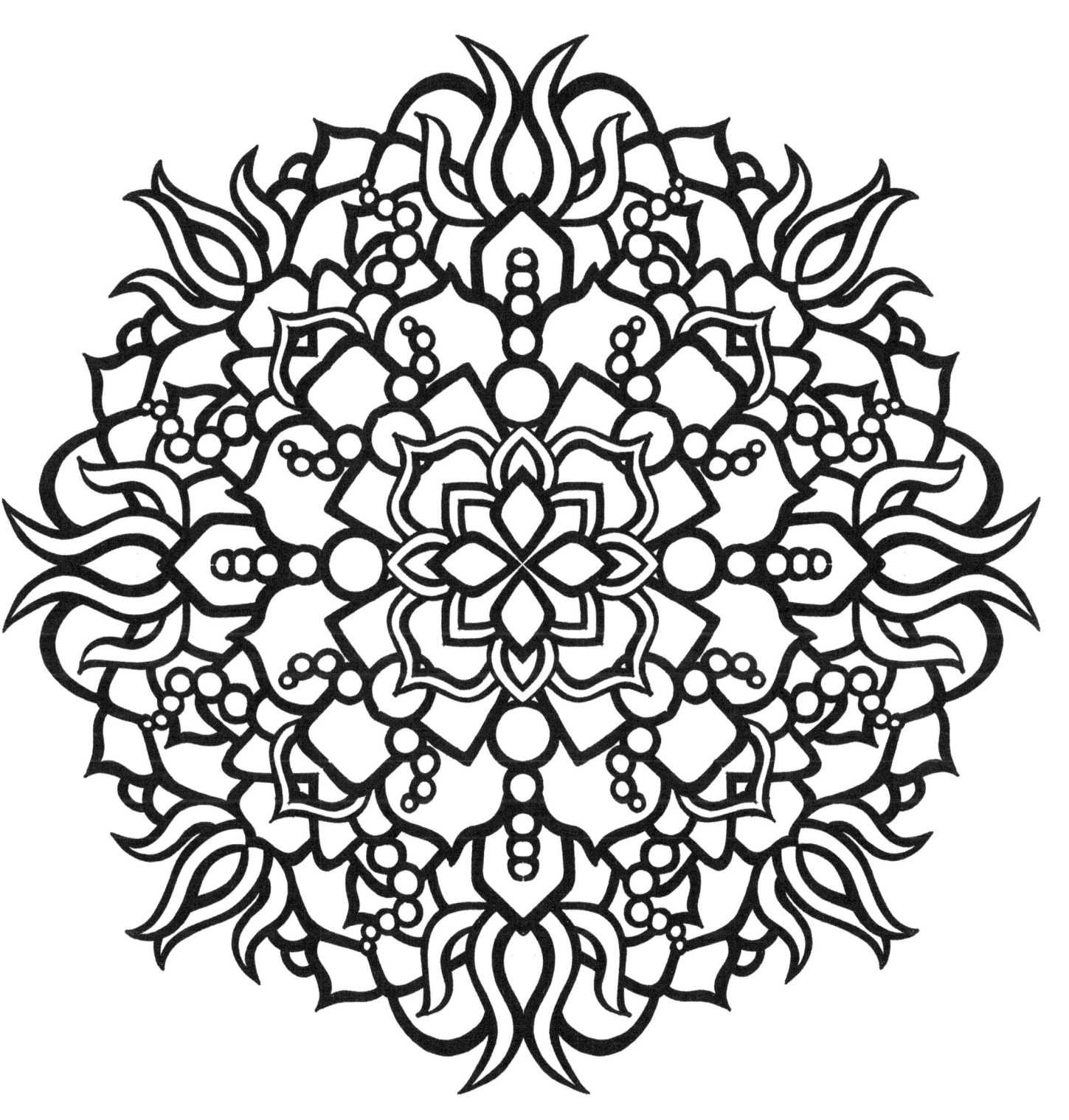

Kaleidoscopics Book 2
"Tulip Turnover"

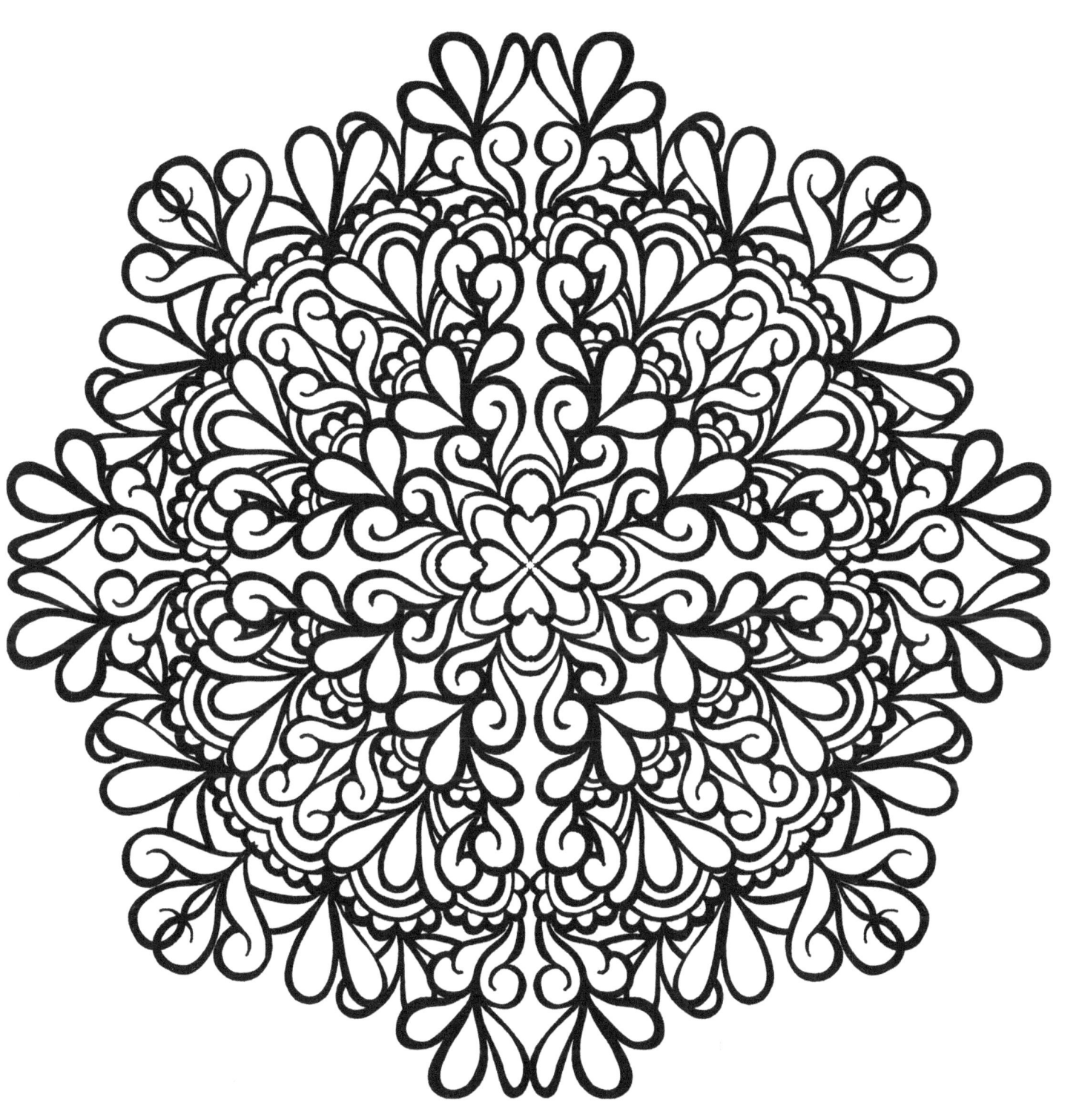

Kaleidoscopics Book 2
"Paisley Prince"

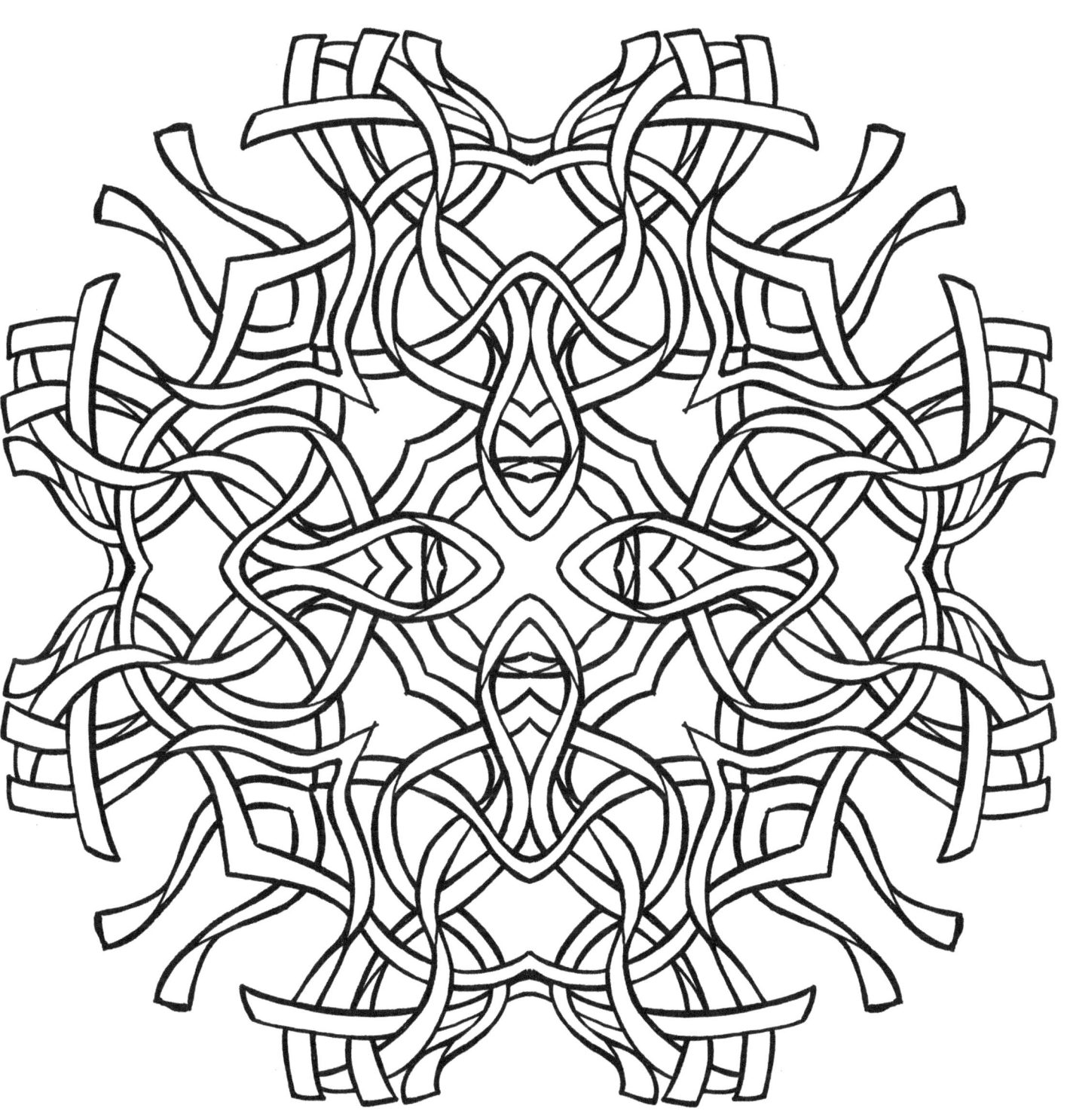

Kaleidoscopics Book 2
"Ribbony"

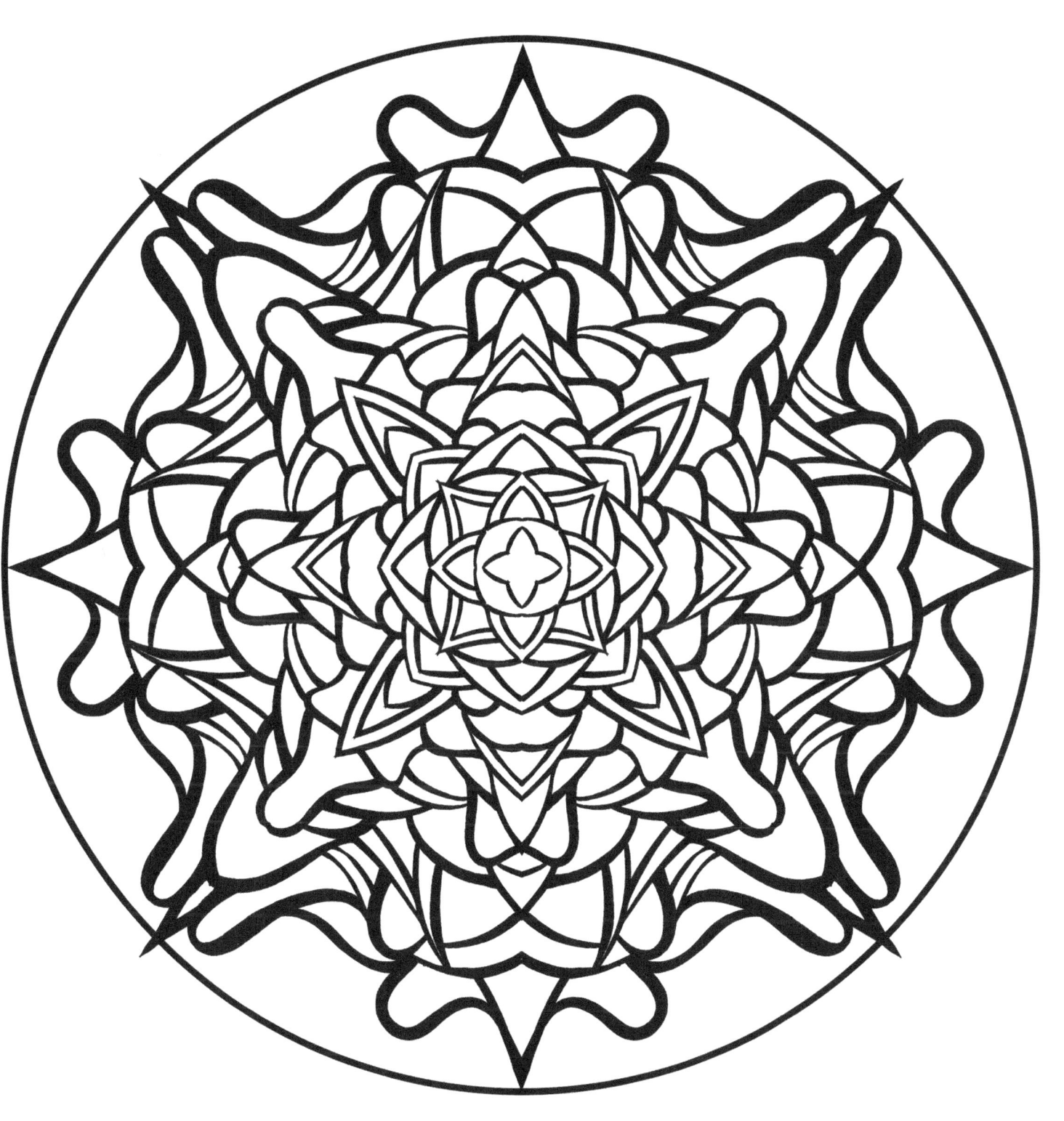

Kaleidoscopics Book 2
"Arch-ery"

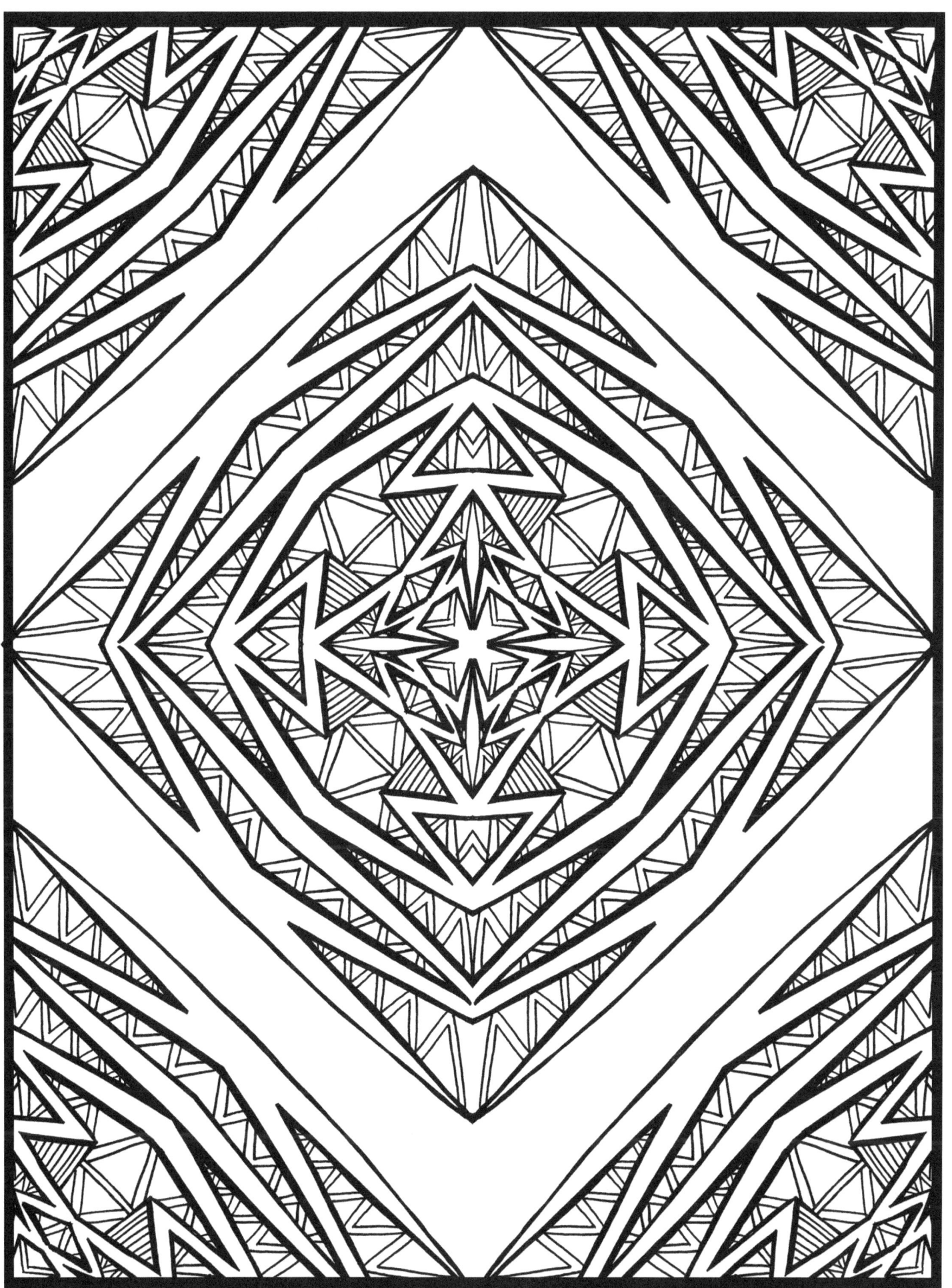

Kaleidoscopics Book 2
"ZigZag Zowie"

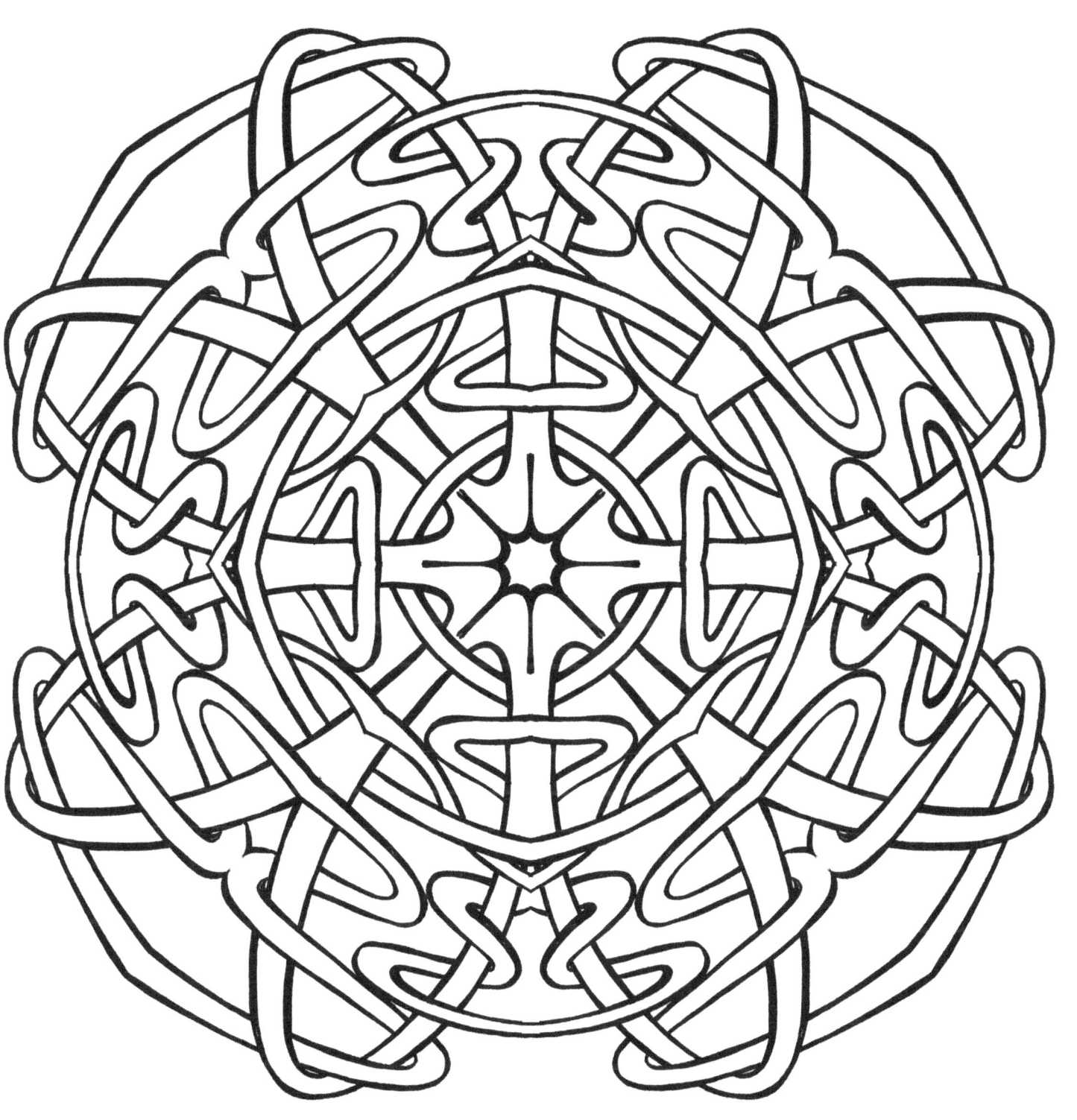

Kaleidoscopics Book 2
"Woven Pathways"

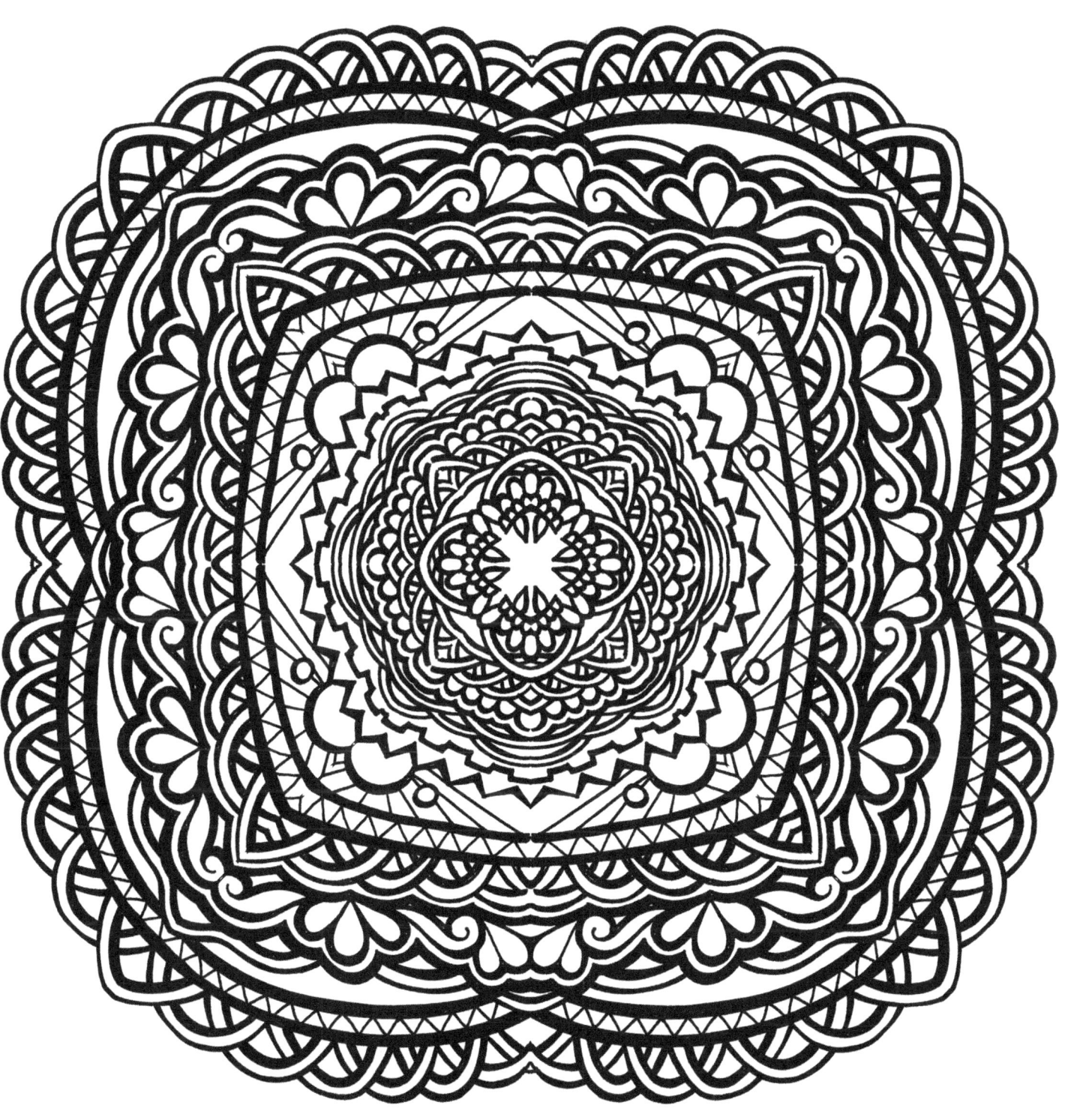

Kaleidoscopics Book 2
"Lacy Doiley"

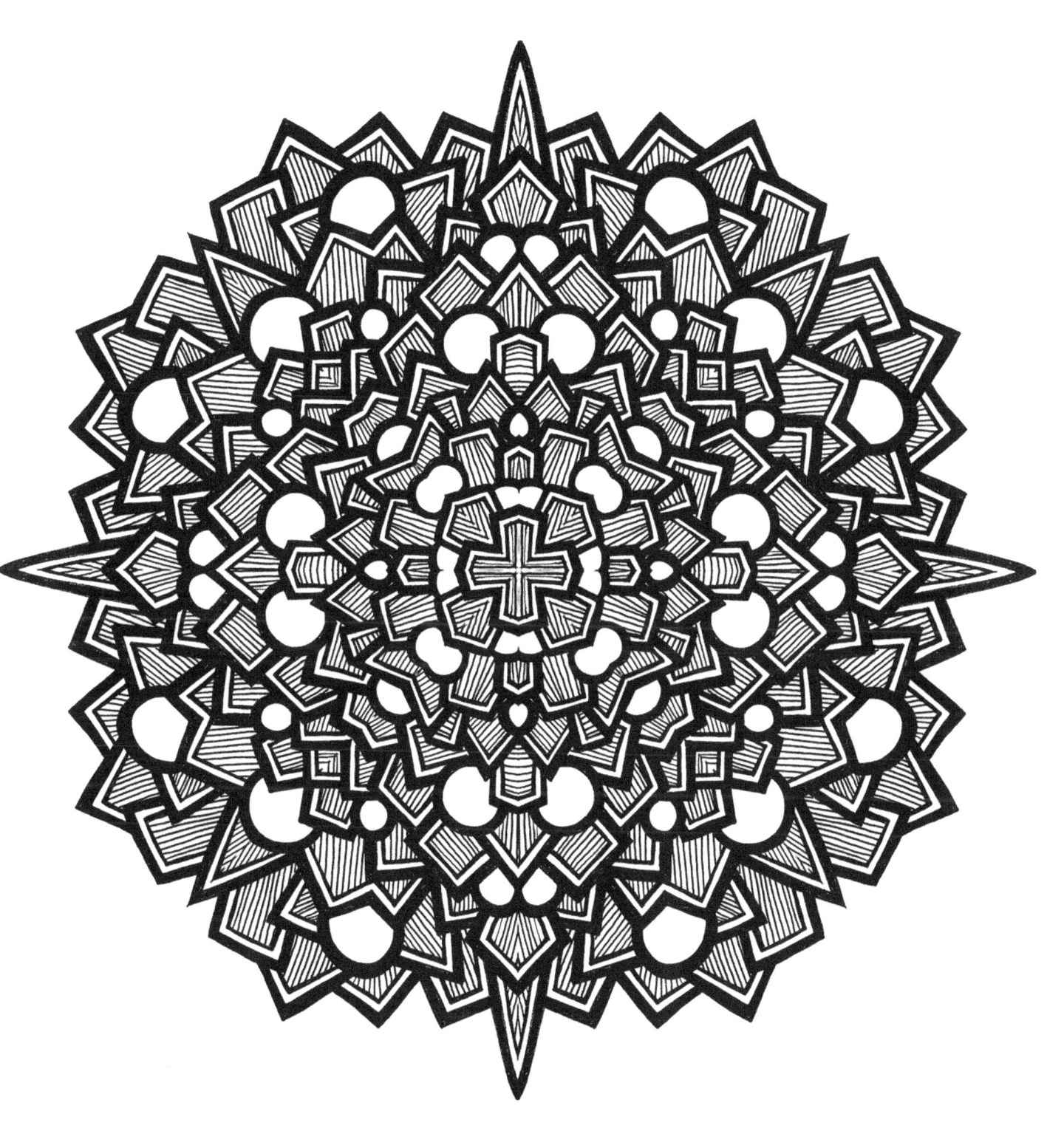

Kaleidoscopics Book 2
"Shaded Fury"

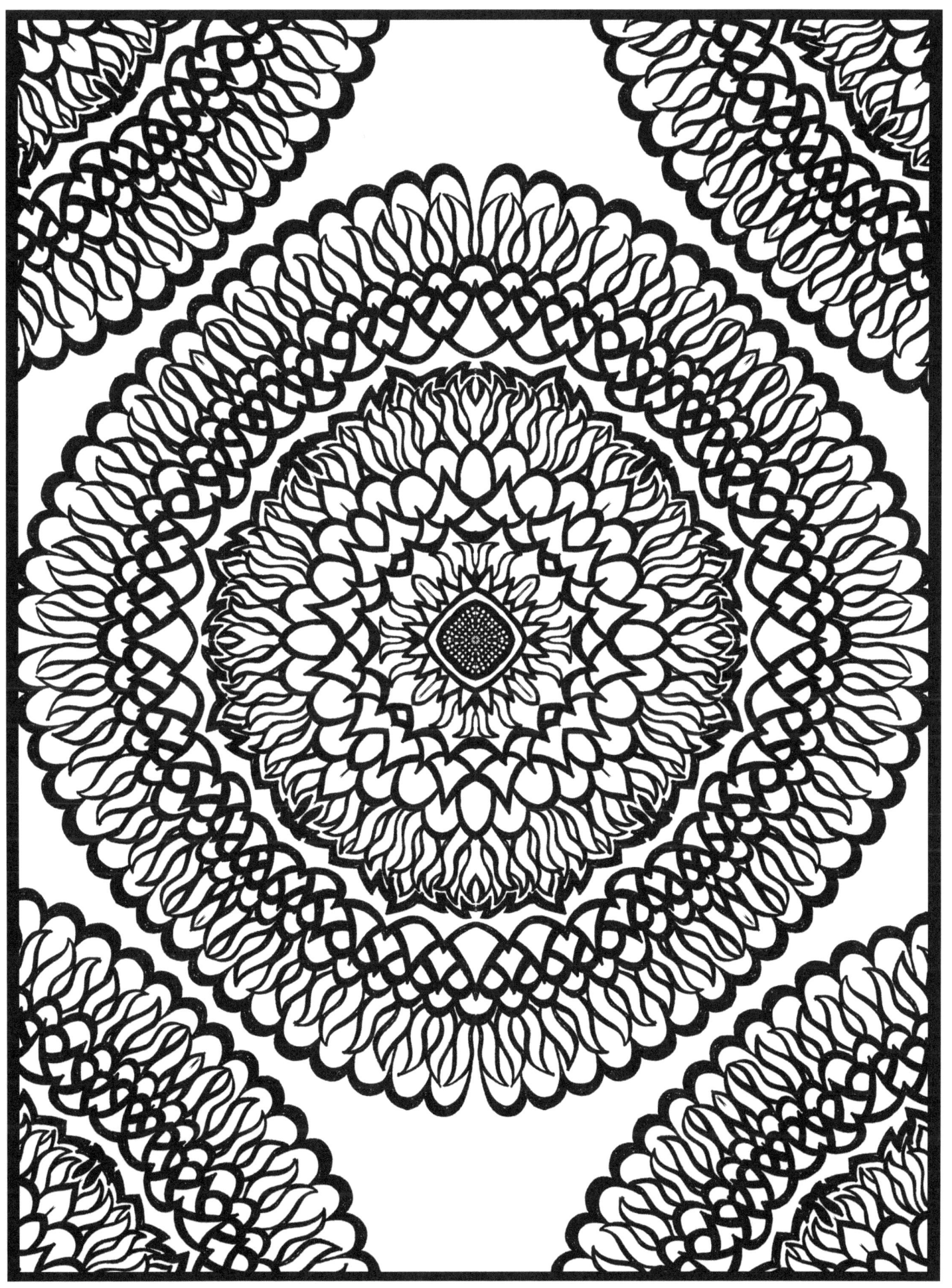

Kaleidoscopics Book 2
"Old Lace"

www.ingramcontent.com/pod-product-compliance
Lightning Source LLC
Chambersburg PA
CBHW080710190526
45169CB00006B/2321